CHARDIN

CHARDIN

Gabriel Naughton

Phaidon Press Limited
Regent's Wharf, All Saints Street, London N1 9PA

First published 1996
© Phaidon Press Limited 1996

A CIP catalogue record for this book is available from the
British Library

ISBN 0 7148 3336 3 Pb
ISBN 0 7148 3337 1 Hb

Printed in Hong Kong

Cover illustrations:
Front: *The House of Cards*, 1736–7 (Plate 22)
Back: *Basket of Wild Strawberries*, 1761 (Plate 39)

The publishers would like to thank all those museum authorities and
private owners who have kindly allowed works in their possession to be
reproduced. Particular acknowledgement is made for the following.
Plate 15: Gift of Mrs John W Simpson, reproduction © 1994 Board of
Trustees, National Gallery of Art, Washington, DC; Plate 40 and Fig.
34: Howard A Noble Collection, Carnegie Museum of Art, Pittsburgh,
PA; Plate 43: James Philip Gray Collection, Museum of Fine Arts,
Springfield, MA; Fig. 26: Guildhall Art Gallery, Corporation of
London; Fig. 35: William R Scott Jun. Fund, Carnegie Museum of Art,
Pittsburgh, PA.

The author would like to thank Monsieur Pierre Rosenberg, Président-
Directeur du Louvre, for kindly agreeing to read the introductory
essay.

Note: All dimensions of works are given height before width.

Chardin

Jean Siméon Chardin was born in 1699 – a significant date since his art owes as much to the seventeenth as to the eighteenth century. This was the era of the Rococo, associated with images of frivolity and pleasure, from the elegant fêtes of Jean-Antoine Watteau (1684–1721) and the erotic nudes or overdressed shepherdesses of François Boucher (1703–70), to the scenes of amorous assignations painted by Jean-Honoré Fragonard (1732–1806). Truth and simplicity seem absent from this artificial world, yet it is these qualities which characterize Chardin's paintings and make him a unique figure in the eighteenth century. Chardin's work belongs to the Realist tradition. His still lifes are unadorned, his laundresses are real people and his children are serious and absorbed. He shows us the real world that he knew, not a Rococo fantasy, and in this he anticipates the Realist painters of the nineteenth century.

Like Boucher, Chardin (Fig. 1) came from a humble artisan background. He was born in Paris and never left the capital except to work in the immediate vicinity at Versailles and Fontainebleau. In 1729 Chardin was one of a team of artists commissioned to work on the scenery for a firework display held at Versailles to celebrate the birth of the Dauphin, the son of Louis XV. Two years later he assisted in the restoration of the sixteenth-century Italian frescos in the gallery of François I at the royal château of Fontainebleau. Chardin was christened in the church of Saint-Sulpice (Fig. 2) in Saint-Germain-des-Prés and continued to live in the same district all his life. Chardin's father was an independent craftsman and master carpenter who specialized in making billiard tables which he supplied to the Royal Household. His younger brother, Juste, was also active in the family business.

Ambitious for his elder son to pursue an artistic career, Chardin's father sent him to study with the now little-known artist, Pierre-Jacques Cazes (1676–1754), who taught him how to draw. His teaching methods were uninspiring, however, as his pupils were taught to draw from his own works, not from real life. By 1720 Chardin is recorded as working with Noël-Nicolas Coypel (1690–1734), a decorative artist and one of the famous Coypel dynasty of painters. Chardin assisted him by painting the still-life accessories in his canvases. In 1724 Chardin entered the Academy of St Luke, the rival institution to the Royal Academy but lacking its royal cachet.

Chardin did not begin by painting still lifes but found his first subject matter in everyday life. His earliest known work is a large shop sign which he painted for a friend of his father who was a surgeon and apothecary. He may have been inspired to paint it because of the success of Watteau, the foremost artist of the day who also worked in this field. In 1720 Watteau had painted a similar sign for his friend, the art dealer Gersaint, on the pont Notre Dame, the famous *Gersaint's Shop Sign* (Charlottenburg Palace, Berlin). The work was such a

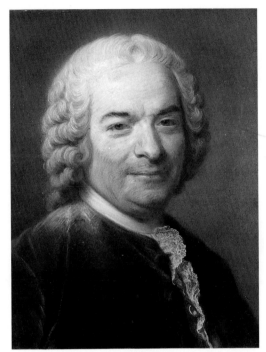

Fig. 1
MAURICE-QUENTIN
DE LA TOUR
Chardin
1760. Pastel on paper,
53 x 45 cm.
Cabinet des Dessins,
Musée du Louvre, Paris

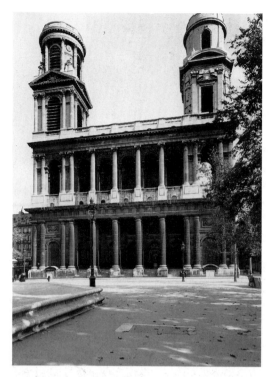

Fig. 2
Church of Saint-
Sulpice, Paris
Photograph.
British Architectural
Library, RIBA, London

Fig. 3
CHARLES-JOSEPH
NATOIRE
Drawing Class at the
Royal Academy
1746. Watercolour and
black chalk on paper,
45.3 x 32.3 cm.
Courtauld Institute of Art,
London

success that according to contemporary accounts 'the most skilful painters came several times to admire it'. Indeed all Paris admired it and Chardin, as a young man of 20, could easily have been inspired by this artistic testament. Although Chardin's shop sign has not survived, a nineteenth-century engraving taken from the sketch does record the image. The scene shows a busy street with a man wounded in a duel being brought to the surgeon's shop for treatment. A preliminary study in charcoal of *A Man Pulling a Handcart* (Nationalmuseum, Stockholm) at the right of the composition is revealing of Chardin's youthful working methods. Early on, he clearly worked from preliminary drawings, although he soon gave up this practice and instead painted directly from what he saw; some of the artist's critics considered this a major failing. There exist only three drawings definitely attributed to the artist. Chardin's earliest surviving painting is *The Billiard Game* (Plate 1) dateable to between 1721 and 1725, which he may have painted in homage to his father. This work also recalls Watteau, whose influence is particularly noticeable in a preliminary figure drawing (Fig. 16).

Chardin's career is well documented. He showed his paintings regularly at the annual Salon exhibition and the Exposition de la Jeunesse, an open-air show held in June in the place Dauphine. Both exhibitions received extensive coverage in the Press. These reviews provide an important insight into contemporary opinion on the artist's work. The most important and instructive views on the Salon in the later part of Chardin's career are those of Denis Diderot (1713–84), the famous French philosopher and editor of the *Encyclopédie*. In addition, his friend and fellow artist, Charles-Nicolas Cochin (1715–90) wrote a biography of the painter after his death and Pierre-Jean Mariette, the celebrated eighteenth-century connoisseur, discussed Chardin at length in his *Abécédario*, a collection of artists' lives. According to both writers, Chardin decided to specialize in still life because he believed painting from nature or from real objects to be just as demanding as history painting; in other words he argued for the reverse of the Academy's doctrine.

The development of all French painters of the eighteenth century must be seen against the artistic background of their day. Their reputations and livelihoods depended, not only at the outset of their careers but throughout their lives, on royal patronage and aristocratic commissions. The Royal Academy of Painting and Sculpture was the embodiment of this patronage. Founded in 1648, the Academy was a powerful institution with a hierarchy and rigid rules. Its first director was the painter, Charles Lebrun (1619–90). The director was responsible to the Surveyor General of the King's Buildings (Directeur Général des Bâtiments du Roi), who was appointed by the King. The Surveyor General had great power, since he could recommend an artist to the King for the commission of a painting or decorative scheme. He was also empowered to grant an artist an annual pension or reward him with a grace and favour apartment in the Louvre, which was then a royal palace. As a teaching institution, the aim of the Academy was to convey the principles of art to its members through lectures and to teach its students by means of practical classes (Fig. 3). Funding came partly from the students and partly from the King. In 1656 the Academy moved into rooms at the Louvre and the first exhibition of works by its members was held there in 1699 in the Grande Galerie, moving to the Salon Carré in 1725. It was in this way that the tradition of the annual Salon exhibition evolved. The formal opening was always held on August 25, the feast of St Louis, in honour of the King. The highest award for a student was to win the *Prix de*

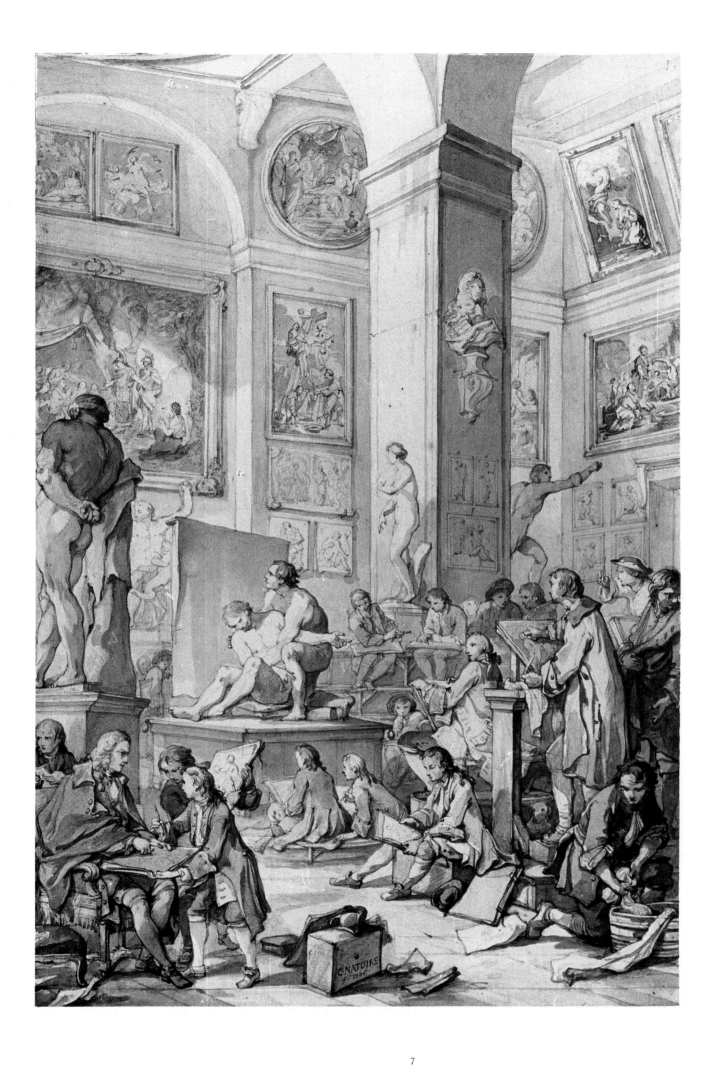

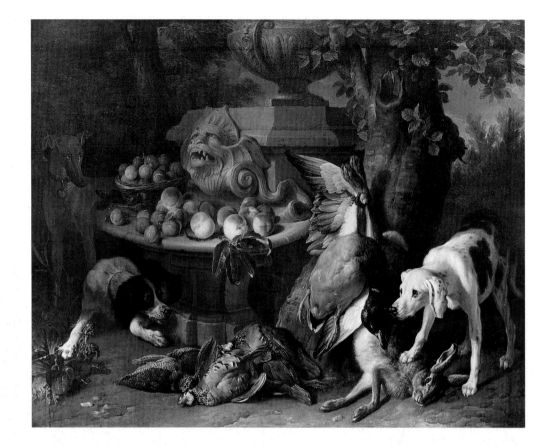

Rome, which enabled him to spend four years in Italy living at the French Academy in Rome. This opportunity to study nature and the Antique as well as Italian painting proved an invaluable stimulus to young artists. For painters such as Boucher, and later in the century Fragonard and Hubert Robert (1733–1808), Rome provided a permanent source of inspiration. After their return from Rome, or when they had completed their studies at the Academy, all the students had to be approved by their seniors by submitting one piece of work to the assembly of Academicians. When they were approved, they had to present a reception piece on a given subject usually within one year. In the case of portraitists or still-life painters, the student had to present two works. The reception pieces then belonged to the Academy.

In the seventeenth century, the Academy had established a hierarchy of genres in painting which was codified in 1667 by its secretary, André Félibien, in a famous lecture. He classified artists' subject matter according to a league table putting subjects from history, the Bible and literature at the top because they were moral or ennobling. Such subject matter was classified as 'grand genre'. All other forms of painting such as portraiture, landscape and still life were considered to be inferior and were classified as 'petit genre'. Artists, likewise, were classified according to the subject matter they painted. The critic, La Font de Saint-Yenne, wrote in 1747: 'The history painter alone is the painter of the soul; the others paint merely for the eye.' Chardin did not have a formal education nor a conventional art training. He did not study at the Academy nor go to Italy and throughout his career he keenly felt a sense of inferiority. Even in old age he is said to have been deeply hurt by the criticism of the artist Jean-Baptiste Marie Pierre (1713–89) that he had never practised the 'grand genre'. However, by the beginning of the eighteenth century the power of the Academy had already begun to decline because of a gradual change in taste. Louis XIV, the absolute

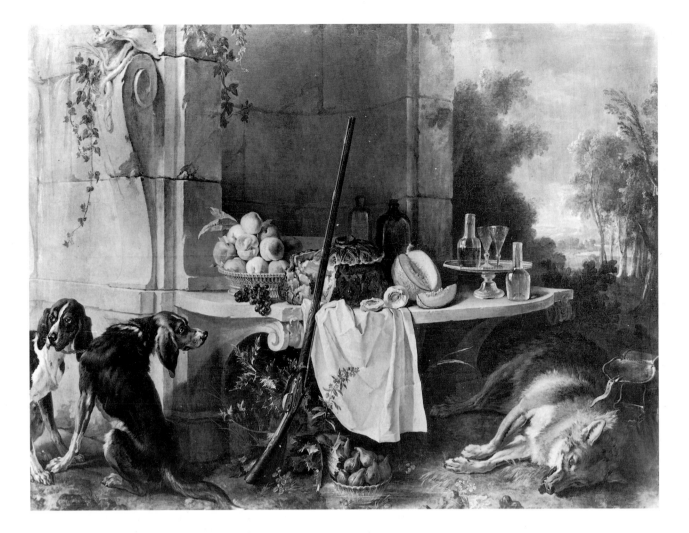

Fig. 5
JEAN-BAPTISTE
OUDRY
The Dead Wolf
1721. Oil on canvas,
193 x 260 cm.
Wallace Collection,
London

monarch, died in 1715 and absolutism in matters of artistic taste and dogma died with him. His successor, the Duc d'Orléans, Regent from 1715 to 1723, preferred Paris to Versailles and court life centred around his royal residence, the Palais-Royal. The aristocracy followed him back to Paris, building themselves smaller residences and developing a taste for Dutch cabinet pictures, which were appropriate for the new style of décor.

It is claimed by both Cochin and Mariette that a decisive moment in Chardin's career came when he was asked to paint a hare or rabbit. His painting was such a success that a commission for a still life of a duck immediately followed. The artist's own words on the subject reveal his quest for originality in this genre:

> I must forget everything I have seen so far and even the manner in which such objects have been treated by others ... I must place [the object] at a distance where I no longer see the details. I ought to occupy myself above all with imitating the general masses well and with the greatest truth – those shades of colour, the volume, the effects of light and shade.

When referring to what he had 'seen so far', Chardin was probably thinking of the two great still-life painters of his day, Alexandre-François Desportes (1661–1743) and Jean-Baptiste Oudry (1686–1755). Desportes and Oudry specialized in still lifes connected with the hunt (Figs. 4 and 5) and both received royal patronage. In 1728, Oudry was appointed official painter to the Royal Hunt. In their paintings, which owe much to Dutch seventeenth-century still lifes, they depict dead

Fig. 6
GASPARD DUCHÉ DE VANCY
The Exposition de la Jeunesse in the place Dauphine
1780. Pencil and wash on paper, 21.3 x 27.5 cm.
Musée Carnavalet, Paris

and live animals, together with the paraphernalia of the hunt – dogs, guns and game-bags, while the remains of a hunting feast frequently form the backdrop. These works, rich in conception, were highly sought after by the aristocracy, since they mirrored their own leisure pursuits. As was said later of Louis XV, when the King was not hunting the diary entry for that day read 'rien' (nothing). Chardin's early paintings such as *The Hunting Dog* (Norton Simon Museum of Art, Pasadena, CA) or *The Buffet* (Plate 4) owe much to the influence of Oudry and Desportes. The artist showed his first still lifes, possibly 10 or 11 canvases, at the Exposition de la Jeunesse in 1728. It was at this open-air exhibition (Fig. 6) that young artists could show their work to the public. Among Chardin's exhibits of 1728 one which received special praise was the now famous work *The Ray-Fish* (Plate 2). The realism of this painting must have been almost shocking to a public accustomed to the smooth, conventional productions of Oudry and Desportes.

The works shown at the Exposition de la Jeunesse were reviewed in a weekly journal, the *Mercure de France*, whose editor, Chevalier Antoine de la Roque (Fig. 7), a patron and friend of Watteau, was one of Chardin's first admirers and one of the earliest collectors of his still lifes. It was in this journal that an advertisement for a print after one of Chardin's paintings first appeared in 1738. On the death of La Roque in 1744, ten of the artist's paintings appeared in his inventory. Because of the success of the *The Ray-Fish* (Plate 2), Chardin was persuaded by his fellow artists to present his work to the Academy. He submitted this picture and *The Buffet* (Plate 4) and as a result was accepted as 'a painter skilled in animals and fruit'. He was made Associate and Academician on the same day, a rare achievement for any painter, especially one not trained by the Academy. He was almost 29.

Until the end of the 1720s Chardin continued to paint still lifes, although not on the grand scale of his two Academy pieces. He

Fig. 7
JEAN-ANTOINE
WATTEAU
Portrait of Antoine
de la Roque
1715–20. Red chalk on
paper, 21 x 16 cm.
Fitzwilliam Museum,
Cambridge

painted mainly small still lifes of only a few objects – a wine bottle, a goblet and fruit, or hares, rabbits or dead game birds hanging from bare stone walls. What distinguished them from the work of his predecessors was their extreme simplicity and realism. For the first time, the viewers felt they could touch the rabbit's fur or taste the sun-ripened peaches. Many of these early pictures were purchased by Chardin's friends and fellow artists, such as the portrait painter Joseph Aved (1702–66), the history painter Michel-François Dandré Bardon (1700–83) and the sculptor Philippe Caffiéri (1714–74).

In 1730, probably through his friend Aved, Chardin met his first important patron, Count Conrad-Alexandre de Rothenbourg (1683/4–1735) who, after a brilliant military career, was appointed Ambassador to the Court of Spain. He was asked to paint three large canvases of musical subjects to fit into the panelling over the doors of the salon of the Count's Paris house in the rue du Regard. In addition he was commissioned to paint two pictures for the library, *The Attributes of the Arts* (Fig. 20) and *The Attributes of the Sciences* (Plate 7). The musical paintings, Italianate in style but still recalling Oudry, are seductively beautiful, while the library canvases are more austere and symbolic. The globe, maps, sculpture and Turkish carpet symbolize the Ambassador's learning and his itinerant lifestyle. Described as Chardin's youthful *chefs-d'œuvre*, they illustrate how quickly the artist had learned how to satisfy a client's demands in painting and how far he had come since his first small exercises in still life.

By 1731 Chardin was sufficiently established to earn a living from

his painting, so he decided to marry his fiancée of eight years, Marguerite Saintard, who was ten years his junior and who came from a well-to-do bourgeois family. They had two children, a son, Jean-Pierre, who was born the same year, and a daughter, Marguerite-Agnès, born in 1733, who died young. The marriage contract of Chardin and his wife tells us much about the standard of living of the young couple, which was simple and comfortable. Many of the household objects which appear in Chardin's paintings of the 1730s are to be found in this contract and in the inventory drawn up at the time of Marguerite's early death in 1735. In 1744 Chardin married a widow, Françoise-Marguerite Pouget, and moved into her house in the rue Princesse. The objects that appear in Chardin's later paintings, such as the Meissen porcelain, belonged to the artist's more prosperous second household. In the early 1730s, due perhaps to his settled domestic life, Chardin began to paint a series of kitchen still lifes, which comprised small paintings of kitchen utensils – copper pans, wooden pepper mills, earthenware jugs, pestles and mortars. Dead game disappears from his paintings and is replaced by simple food – fish, eggs, onions and leeks. The artist arranges these objects with minute care and attention, nearly always on a stone ledge where he carefully paints his signature. All he is concerned with is the form of the objects – round or angular, smooth or sharp and the beauty of their materials – the dull iron of the kitchen pans, the glaze of the green earthenware jug or the shining copper of the cauldron. He paints the light as it falls upon them, reflecting their dull or polished surfaces. Painted in subdued tones of greys and brown-reds against the dark or neutral background of a stone wall, the only raw matter in these pictures is the slippery fish or blood-red meat that hangs on a hook or a freshly picked vegetable. Occasionally the artist introduces a white cloth to bring a soft texture into this hard array of stone and metal. There is no superfluous detail, however, or search for decorative effect. The beauty of these pictures lies in their minimalism. Over the next five years Chardin created variations on a theme within this limited repertory. He experimented by painting on different supports. Thus the most famous pair of paintings in this series, *The Feast Day Meal* (Fig. 21) and *The Fast Day Meal* (Plate 8) are painted on copper, while one of the most perfect examples, the small *Copper Cauldron with Three Eggs* (Plate 10) is painted on panel. Although antecedents for this type of kitchen still life exist in the work of Dutch seventeenth-century painters such as Willem Kalf (1619–93), whose work was extremely popular in France, Chardin's treatment of this theme is entirely original. In these paintings, which are almost sombre in their subject matter, he gives life to inanimate objects, infusing them with warmth and magic. The painting that forms the climax to this series is *The Copper Water Urn* (Plate 11). The object itself is carefully described in the inventory of Chardin's first wife's effects as being made of red copper with copper handles and a Chinese wooden stand. Although Chardin was to use the copper urn as a prop in two of his most famous genre paintings, the *Woman at the Urn* (Plate 13) and *The Return from Market* (Plate 29), in this painting it takes on monumental proportions. This work was to have a major influence on nineteenth-century French still-life painters such as François Bonvin (1817–87) and in the twentieth century on Paul Cézanne (1839–1906).

By 1732 Chardin had replaced Oudry as the public's favourite painter at the Exposition de la Jeunesse. His still lifes were described by one critic thus: 'One is reduced to the point that one must absolutely place a hand on the canvas and touch the picture in order to

comprehend the painter's artifice.' In spite of this success, however, it was at this very moment that he decided to abandon still life. According to anecdotal evidence he was hurt by a mocking remark from his friend, Aved, that portrait painting was not nearly so easy as painting still lifes. In addition, despite his success at the Salon, Chardin had found no new buyers or patrons among the aristocracy or the *nouveaux riches*, the bankers and financiers who were building and decorating their new houses in the capital. He decided to return, therefore, to the genre painting he had experimented with at the very beginning of his career, and throughout the 1730s he exhibited mainly genre subjects at the Salon, which had reopened in 1737 after many years of closure due to lack of funds. His new paintings bear no relation to his early works, however, although they do contain elements from his still lifes. They fall into three groups – female figure paintings, portraits of children (rarely specific portraits), or a combination of women and children. Unlike Boucher's ornate Rococo interiors, Chardin's figures are depicted in the simplest of surroundings and, unlike Boucher's elegant models (Fig. 8), Chardin's women are portrayed almost exclusively at work. They are servants, mothers, governesses and only rarely ladies of leisure. His children, however, are portrayed almost exclusively at play although their games have an underlying symbolism. They are the children of the bourgeoisie not the aristocracy.

Like so much of his art, the genesis of Chardin's genre paintings

Fig. 8
FRANÇOIS BOUCHER
Woman Fastening her Garter
1742. Oil on canvas,
52.5 x 66.5 cm.
Fundación Colección
Thyssen-Bornemisza,
Madrid

is to be found in the work of his Dutch seventeenth-century predecessors whose work was very much in vogue in eighteenth-century Paris. Small Dutch cabinet pictures suited the more intimate scale of décor in the decades that followed the death of Louis XIV, as people reacted against the overwhelming grandeur of aristocratic life during his reign. The Marquis d'Argens who upheld the grand style of painting wrote: 'Today, to the enduring shame of the arts, one sees so-called lovers of painting forming large collections of little Dutch pictures which they buy at exorbitant prices.' When the Comtesse de Verrue (1670–1736) died in Paris and her collection of paintings was sold the following year, it contained 25 works by the famous Dutch genre painter David Teniers (1610–90). Dutch genre paintings were also popularized by means of engravings and artists collected these prints in huge numbers, frequently using them as sources for their own paintings. The earliest of Chardin's genre paintings is a subject favoured by such seventeenth-century artists as Gabriel Metsu (1629–67) or Gerard Ter Borch (1617–81), the *Lady Sealing a Letter* (Plate 12), exhibited in 1734. It is painted on a grand scale and almost baroque in terms of size and feeling, and Chardin's female sitter is unusually richly attired in silk. Her haste in sending her letter to her lover is symbolized by the greyhound at her lap. This painting is also very close to so many of the amorous subjects being painted at this time by Chardin's contemporaries such as Jean-François de Troy (1679–1752). The monumentality of the female figure was to become a recurring motif in Chardin's genre paintings of the 1730s. The *Lady Taking Tea* (Plate 18), painted two years later, shows the sitter wearing

the same striped dress and both works may represent the artist's first wife, Marguerite.

Chardin's choice of subject matter, the portrayal of daily life, although rooted in Dutch painting, may also have been engendered by his happy domestic life. He had married in 1731 and by 1733 his two children had been born. The subjects of the next group of paintings describe the daily routine of the household but the still-life elements dominate the compositions. The female figure in *Woman at the Urn* (Plate 13) is secondary and seems to form part of the still life, since her face is almost hidden from the spectator. Although she is present in the painting, there is almost no human element. Chardin frequently painted his genre subjects in pairs and in this he is unique. Thus the *Woman at the Urn* (Plate 13) has as its companion piece *The Laundress* (Plate 14). These works were commissioned by La Roque, Chardin's early champion, and they were exhibited at the Exposition de la Jeunesse in 1734 or 1735 when the artist was described as showing paintings in the 'style of Teniers'. The paintings of Teniers were extremely popular in eighteenth-century France; the Duc d'Orléans owned nine of his works. Chardin's exhibits were praised for their 'great truth' and 'rare intelligence'. Indeed they contain an element that was to characterize all his genre paintings and which makes him unique – his ability to capture the absorption of his sitters in their work and the silence that envelops them. They appear to us other-worldly and removed from reality, although they are performing the most mundane of domestic tasks. The woman in *The Laundress* (Plate 14) is as lost in thought as the child blowing soap bubbles at her feet, a motif from Dutch painting symbolizing the transitory nature of human life. Comparable to this pair are the famous paintings of *The Scullery Maid* (Plate 28) and *The Cellar Boy* (Fig. 29), which were purchased in the artist's lifetime by the celebrated Scottish physician Dr William Hunter (1718–83) (Fig. 9) and subsequently given to the Hunterian Art Gallery, Glasgow. Again we recognize the familiar objects from Chardin's kitchen still lifes but now the human figures dominate. The summit of Chardin's achievement in this genre is undoubtedly *The Return from Market* (Plate 29) of which Chardin painted two versions in 1738 and 1739, one of which he showed at the Salon of 1739. In this painting Chardin repeated a compositional device frequently found in Dutch seventeenth-century painting, which he had used in *The Laundress* (Plate 14), of a door opening from a dark interior into a space filled with light. *The Return from Market* (Plate 29) is one of the artist's most beautiful creations, not only because of the perfection of the composition and the restrained use of colour but in his tenderness for this large country girl, laden with provisions, as she leans for a moment's rest against the heavy sideboard. Although to twentieth-century viewers she recalls the *Kitchen Maid* (Rijksmuseum, Amsterdam) of Jan Vermeer (1632–75), as do so many of Chardin's female figures, Vermeer's work was unknown in France in Chardin's day.

While he was engaged on his female genre painting, Chardin also treated the subject of childhood and adolescence in a number of child portraits. Although some were specific commissions such as the two separate portraits of the children of the jeweller, Charles Godefroy, others appear to be simply portrayals of children at play; they blow bubbles, spin tops or construct houses of cards. The symbolism of seventeenth-century Dutch paintings is again inherent in Chardin's subject matter, bubbles signifying the transience of human life or the inconstancy of love, spinning tops and houses of cards alluding to the futility of human ambition. Although the children play, their faces are

Fig. 10
The Monkey as a
Painter
1735–40. Oil on canvas,
28.5 x 23.5 cm.
Musée des Beaux-Arts,
Chartres

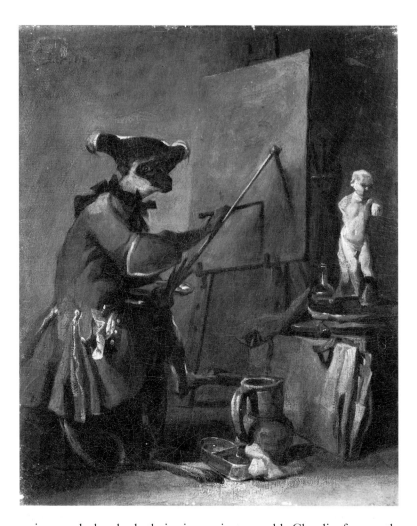

serious and absorbed; theirs is a private world. Chardin frequently painted portraits of children in pairs just as he did with his female genre paintings. Thus the *Girl with Shuttlecock* (Plate 23) is a pendant to *The House of Cards* (Fig. 28). Another of Chardin's favourite themes was the subject of the young painter or draughtsman with whom he doubtless identified. The beautiful *Young Student Drawing* (Plate 20) is a compelling image. It was painted as a pendant to *The Embroiderer* (Plate 19) and both may have been commissioned by La Roque. In 1745 they were acquired at the La Roque sale by the dealer Gersaint for Prince Adolf Frederick (1710–71), the future King of Sweden. At the same sale Gersaint acquired 11 Dutch seventeenth-century paintings by artists such as Ter Borch, Nicolaes Berchem (1620–83), Teniers and Adriaen van Ostade (1610–85), illustrating the continuing vogue for Dutch paintings in Northern Europe. Although we cannot see the face of the artist in the *Young Student Drawing* (Plate 20), his concentration is apparent in his hunched back and shoulders as he bends over his paper, carefully copying another artist's drawing. Perhaps in this painting, exhibited at the Salon of 1738, Chardin was remembering his own hard days as a student, vividly recalled late in life when he wrote that such work often reduced him to tears. Chardin painted six versions of this tiny work, more than any other subject in his *œuvre*. At around the same time he satirized the idea of the painter as copyist in his painting *The Monkey as a Painter* (Fig. 10), a theme also treated by Teniers. These monkey paintings by Dutch and Flemish artists, known as *singeries*, were extremely popular in eighteenth-century Paris.

It is possible that Chardin was aware of the concern felt in early eighteenth-century France for children's welfare and education and

this may have led him to his next choice of subject matter. In 1687, François Fénelon, the prelate and tutor to Louis XIV's grandson, the Duke of Burgundy, had written the *Treatise on the Education of Girls* and in 1699, the year of Chardin's birth, he had written a pedagogical novel for the young Duke entitled *The Adventures of Telemachus*. This book, which was widely read in the first half of the eighteenth century, extolled the virtues of truth, sincerity and childish innocence. Fénelon's novel was in fact a thinly veiled attack on the luxury and moral decay of life at the court of Louis XIV. The ideas of the English philosopher John Locke, the author of *Some Thoughts Concerning Education*, published in 1693 and translated into French in 1695, also had great influence in France. According to French theorists children's education was a mother's most important task; it was therefore natural that writers and philosophers should be concerned with the position of women in society. Two famous English writers, Joseph Addison and Richard Steele, who founded the journals the *Tatler* (1709) and the *Spectator* (1711–12), which were very influential in France, both favoured improvement in the position of women. In the early 1720s Marivaux, the writer and editor of the *French Spectator*, expressed progressive views on women, marriage and the upbringing of children in his plays such as *The School for Mothers* (1732) and *The Mother as Confidante* (1735). In 1745 a critic wrote of him: 'Marivaux is the most exceptional genius in France ... he writes like Chardin paints.' Coypel, Director of the Academy from 1714, advised painters in his *Discours* of 1721 to seek inspiration in the theatre. Therefore, in this artistic climate, it was not unnatural for Chardin to paint idealized images of motherhood and to portray his women and children in the home, removed from the corruptions of society. That the woman's role is educative is apparent in such works as *The Schoolmistress* (Plate 21) and later *The Governess* (Plate 30). Chardin, however, is not only dealing with contemporary subject matter. These two-figure subjects are a development on the portraits of children and at the same time show how the artist could convey, through the medium of paint, the affection of the sister for her younger brother, and the amusing dialogue that is taking place between them. *The Governess* (Plate 30), which was shown at the Salon of 1739, is Chardin's most successful painting in this genre. A drama takes place between the adult and the child who leaves for school, his playthings abandoned, while looking remorsefully at his dutiful governess who brushes his hat. The same silent dialogue, like an act from a play, takes place in *The Diligent Mother* (Plate 31), which Chardin showed at the Salon of the following year with the more famous *Saying Grace* (Plate 32). This pair of paintings represents the summit of Chardin's achievement in genre painting. They received critical acclaim at the Salon of 1740 and in November of that year, when the artist was presented to Louis XV at Versailles by his Minister for Culture, Philibert Orry (1689–1747), he made a gift of them to the King. Orry had been responsible for the re-establishment of the Salon exhibitions in 1737. In the nineteenth century, however, *Saying Grace* (Plate 32) was thought to indicate the beginning of a change in Chardin's style.

Chardin's genre paintings of the 1740s are different both in style and feeling. In 1742, because of a serious illness, he showed no pictures at the Salon and throughout the 1740s his number of Salon exhibits began to dwindle. In 1743 he was elected Adviser to the Academy, an important function to which he was apparently devoted and which undoubtedly left him less time for painting. In 1745, a year after his second marriage to Françoise-Marguerite Pouget, their only child, Angélique-Françoise, died when just six months old. All these

Fig. 11
JOSEPH AVED
Portrait of Count Carl
Gustav Tessin

1740. Oil on canvas,
149 x 116 cm.
Nationalmuseum,
Stockholm

events clearly contributed to the changes visible in the artist's work. The critic, La Font de Saint-Yenne, was probably voicing a generally held opinion when he wrote in 1747 that Chardin was painting 'only for his own amusement and therefore very little'. Although Chardin continued to paint genre subjects they tend to be of single female figures who are elegant bourgeoises rather than robust servants. The interiors, too, are more refined and sedate and all these works betray an air of restraint and melancholy. Some critics believe that in these late genre pictures Chardin's depiction of women reflects contemporary views on the ideal woman. The contributor to Diderot's *Encyclopédie* of 1751 defined the ideal woman thus:

> Her happiness lies in her ignorance of what the world calls pleasures, her glory is to live unknowing, confined to her duties as wife and mother, she devotes her days to the practice of modest virtues: occupied in running her family, she rules her husband with kindness, her children with tenderness, her servants with goodness; her house is the home of religious feeling, of filial piety, of conjugal love, of maternal tenderness, of order, of inner peace, of untroubled sleep and of health; economical and settled, she is averted from passions and wants ... she emanates a gentle warmth, a pure light which illumines and brings to life all that is around her. Is it nature that has disposed her thus, or reason which has led her to the supreme rank where I see her!

The writer then goes on to criticize the coquettish, materialistic woman whom we see so frequently depicted in French eighteenth-century paintings and especially in the work of Boucher.

In 1741 Count Carl Gustav Tessin (1695–1770), the Swedish Ambassador to the French Court from 1739 to 1742, commissioned from Chardin *The Morning Toilet* (Plate 33), which the artist showed at the Salon the same year. Count Tessin (Fig. 11) was a great admirer and collector of contemporary French painting and was instrumental in forming the collection of French paintings at the Swedish Court, now the nucleus of the Nationalmuseum, Stockholm. Count Tessin loved Chardin's work and when La Roque died in 1745 he acquired four of Chardin's paintings at his sale and in addition ordered versions of *The Diligent Mother* (Plate 31) and *Saying Grace* (Plate 32). *The Morning Toilet* (Plate 33), which shows a mother adjusting her daughter's bonnet before they set off for church, was an enormous success at the Salon. The most enlightening comment on it came from an anonymous critic who wrote:

> It is always the *Bourgeoisie* he [Chardin] brings into play ... There is not a single woman of the Third Estate [the bourgeoisie], who does not think it an image of her figure, who does not see there her own domestic establishment, her polished manners, her countenance, her daily occupations, her morals, the moods of her children, her furniture, her wardrobe.

As a twentieth-century critic later wrote: 'To the Parisian bourgeoisie of his day, Chardin presented a self-image; they looked and saw reflected in his art the image of an ideal of daily life to which they aspired.'

Count Tessin's enthusiasm for Chardin's work must have inspired Princess Louise Ulrike of Sweden, the sister of Frederick of Prussia, to commission two works from the artist in 1745. Although the subjects the Princess had requested, *The Gentle Education* and *The Severe*

Education were not executed, Chardin sent her instead two paintings entitled *Domestic Pleasures* and *Household Economy* (both in the Nationalmuseum, Stockholm). Chardin took over a year to paint these and, in an exchange of letters that have survived, the Princess frequently complains of the artist's slowness, comparing him unfavourably with Boucher, who was capable of working at great speed. When the paintings were finally delivered in 1747, however, the Princess wrote ecstatically to her mother that they were in her possession and Count Tessin's comment was that, 'The Chardin paintings are such that one feels like getting down on one's knees in front of them.' In 1749 the Princess commissioned two more works, *The Good Education* (Museum of Fine Arts, Houston, TX) and *The Study of Drawing* (Fuji Art Museum, Tokyo). Chardin's success with this type of elegant genre painting led to his receiving a number of commissions from the aristocracy of Europe, especially those resident in Paris. Prince Joseph Wenzel of Liechtenstein (1696–1772), who was Austrian Ambassador to the French Court from 1737 to 1741, had acquired at that time three of Chardin's paintings, *The Governess* (Plate 30), *The Return from Market* (Plate 29), and *The Turnip Scraper* (National Gallery of Art, Washington, DC). Around 1747 he commissioned the artist to paint the beautiful *Convalescent Meal* (National Gallery of Art, Washington, DC), which although shown at the Salon of 1747, remained unseen until the nineteenth century when the Goncourt brothers, Jules and Edmond, visited the Liechtenstein Gallery in 1860. The mystery of this work lies in the artist's combining of a perfect still life with the elegance of the fragile female figure. Finally, in 1751, Chardin received royal recognition when Le Normant de Tournehem, Surveyor General of the King's Buildings, commissioned him to paint through the agency of Charles-Antoine Coypel (1694–1752), then First Painter to the King, *The Bird-Song Organ* (Plate 34). The artist acknowledged his debt to Coypel by including in his work two engravings after Coypel's paintings which are visible on the drawing-room wall. It is likely that the sitter in this picture and *Domestic Pleasures* (Nationalmuseum, Stockholm) is the artist's second wife and the sophisticated taste of the interior is probably an accurate representation of their house in the rue Princesse. Looking back at Chardin's works of the 1740s, we can see how far his genre paintings have evolved from his first experiments in this field ten years previously, but also how faithful he remained to his Dutch seventeenth-century predecessors.

Just as Chardin had turned from his successful still-life paintings to experiment with genre painting, so at the height of his fame in 1751 he returned to his first love, still life. By then his work had received royal approbation and in social and economic terms he was comfortable. The revenue from the sale of engravings after his genre paintings assured him a steady income. In 1752 the King had awarded him the first of a number of pensions and in 1757 he was given an apartment in the Louvre. It was in this year that Chardin's son, Jean-Pierre, who was training to be a painter at the Academy, quarrelled violently with his father over his mother's will. The same year he left for Rome. At that time Chardin's duties at the Academy were increasing; he was appointed Treasurer in 1755 and in 1761 he was put in charge of hanging the Salon exhibition (Fig. 12), an extremely delicate task with the amusing title of *tapissier*, which literally means tapestry-maker. Hanging the Salon paintings was an intricate and unenviable task, since the *tapissier* had to try and satisfy all exhibiting artists with his arrangement. Although Chardin continued to exhibit genre paintings at the Salon, they were either repetitions of earlier works or they had

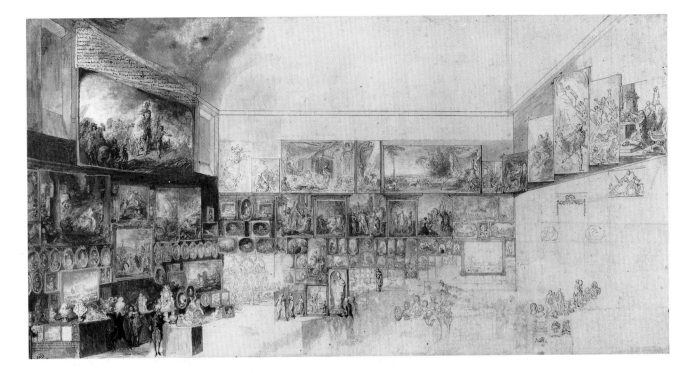

actually been painted some years before. His still lifes of the 1750s, however, are quite different from those of the 1720s. First there is a greater range of objects which now includes fine porcelain and exotic fruit. For the first time, the artist experimented with oval paintings. Generally, however, the objects are richer but the compositions are more classical. The artist gives his objects more space. His style is smoother and more polished, the rougher character of his youthful work has disappeared. In the painting of dead game there is often a touching note or detail, as in the delicate string that lies near a dead partridge's throat. Just as Chardin made us feel for his tired servants, so we feel for the dead game birds which appear as innocent victims of the hunt rather than sporting trophies. From this period dates the one flower painting by Chardin that has survived, although he is recorded as having painted others; this is the beautiful *Flowerpiece: Carnations, Tuberoses and Sweet Peas* (Plate 35). From this elegant arrangement of flowers, a few petals fall, an image symbolic of the transience of life and beauty. As in his earlier productions of the late 1720s and early 1730s, Chardin frequently painted his still lifes in pairs. Two of the most striking are the pair of ovals which he exhibited at the Salon of 1761, *The Jar of Apricots* (Plate 37) and *The Sliced Melon* (Fig. 33). Diderot, however, the most influential critic of the 1750s and 1760s, reserved unequivocal praise for *The Olive Jar* (Plate 38), shown at the Salon of 1763. Diderot claimed that if he wanted his son to become a painter, he would tell him to copy this work again and again. He also notes that the young artist Jean-Baptiste Greuze (1725–1805) is said to have heaved a sigh as he walked past Chardin's painting at the Salon and, in Diderot's words, 'That praise is briefer but better than mine.' At this period Chardin also produced some paintings of great simplicity, the *Basket of Wild Strawberries* (Plate 39) and *Glass of Water and a Coffee Pot* (Plate 40). Works such as these had enormous influence on the French Realist painters of the nineteenth century.

In 1764 Cochin, a friend of Chardin and Secretary to the Academy, submitted to the Marquis de Marigny, the brother of Madame de Pompadour and Surveyor General of the King's Buildings, a decorative project for two of the salons in the royal château at Choisy outside Paris. His plan was to commission artists such as Carle van Loo

Fig. 12
GABRIEL DE SAINT-AUBIN
The Salon of 1765 at the Louvre
1765. Black chalk, pen and ink and watercolour on paper, 24 x 46.7 cm.
Cabinet des Dessins, Musée du Louvre, Paris

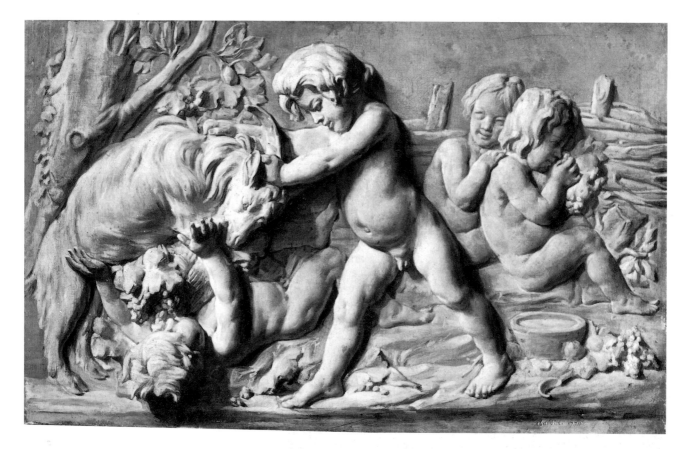

Fig. 13
Autumn
1770. Oil on canvas,
51 x 82.5 cm.
Pushkin Museum of Fine
Arts, Moscow

(1705–65) and Boucher to do the history paintings in the Salle des Jeux and for Chardin to paint three canvases to go over the doors in the Salon de Compagnie. The three subjects Cochin specified were *The Attributes of the Arts* (Fig. 36), *The Attributes of the Sciences* and *The Attributes of Music* (Plate 44). Unlike the history paintings, Chardin's works found favour with the King, although he did not receive payment for them until 1772. They remained in the château until the Revolution and are now in the Louvre although one, *The Attributes of the Sciences*, has disappeared and was probably sold by the Revolutionary Administration. These works which recall Count de Rothenbourg's early commissions of 1731 (Plate 7 and Fig. 20) are far more sophisticated. In *The Attributes of the Arts* (Fig. 36), Chardin paid special homage to his friend, the sculptor Edme Bouchardon (1698–1762), who had died two years previously, by including in it one of his plaster casts. Chardin and Bouchardon had been friends since the 1730s and the sculptor owned one of Chardin's early still lifes. The critic, Théophile Thoré, could have been thinking of these paintings when he contrasted the talents of Chardin and Oudry by saying, 'All Chardin's decoration is truthful and powerful painting, all Oudry's painting is clever decoration.' Sculpture was a great inspiration to Chardin at this period. This is evident from some beautiful grisailles he painted in imitation of sculpture in the late 1760s and early 1770s. Chardin had first experimented with sculptural grisailles in the 1730s, when they were well received at the Exposition de la Jeunesse. In his youth Chardin had copied the works of the Flemish sculptor François Duquesnoy (1597–1643). His bronze relief of *Eight Children Playing with a Goat* (Musée du Petit Palais, Paris) was frequently incorporated by Dutch seventeenth-century artists into their paintings and often appears in the works of Gerard Dou (1613–75), for example in his *Trumpet Player* (Musée du Louvre, Paris). In old age, however, Chardin was more inspired by the work of contemporary sculptors. One of his most beautiful grisailles is *Autumn* (Fig. 13), copied from

22

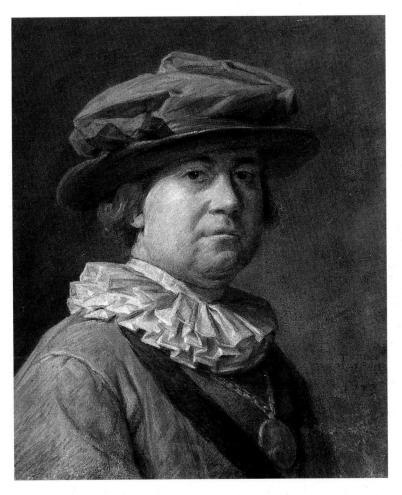

Fig. 14
Head of a Man
1773. Pastel on paper,
55 x 45 cm.
Fogg Art Museum,
Cambridge, MA

one of Bouchardon's plasters for the bas-reliefs of the *Seasons* which adorn his fountain in the rue de Grenelle. Commissioned in 1739, the fountain was one of the major monuments erected in Paris in Chardin's lifetime. The plaster shown at the Salon of 1741 was extremely popular because of its playful subject matter which is typical of the Rococo. In 1766 Louis XV decided to refurbish for his daughters the château de Bellevue, which had been built for Madame de Pompadour in 1748. Her brother, the Marquis de Marigny, again called upon Cochin to devise a decorative programme. The painters, Jean-Jacques Lagrenée (1739–1821) and Fragonard among others, were enlisted to carry out the decorations. Cochin suggested that Chardin should produce the paintings to go over the doors in the music room since in his words: 'This artist has achieved a degree of perfection unique in his genre.' Chardin's works, *The Attributes of Civilian Music* and *The Attributes of Military Music* (both in private collections) were completed by the summer of 1767 and shown at the Salon that year. These works were not seized at the time of the Revolution but were sold when the contents of the château were auctioned in 1794. Like the paintings for the château at Choisy, these two ovals are sumptuous compositions but they are painted on an even grander scale. They contrast gentle instruments – violin, flute and tambourine – with the instruments of war – drums, trumpet and cymbals. It was probably as a result of the success of the paintings for the château at Choisy at the Salon of 1765 that Catherine the Great of Russia (1729–96) commissioned Chardin the following year to paint a canvas to go over the door of the Academy of Fine Arts in St Petersburg, another painting of *The Attributes of the Arts and their Rewards* (Plate 45). Just as he had paid homage to Bouchardon in the painting for Louis XV, in the

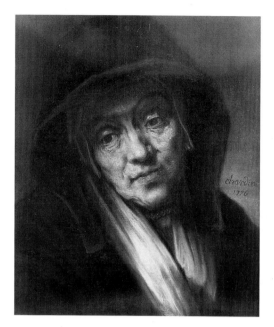

Fig. 15
Head of an Old
Woman
1776. Pastel on paper,
46 x 38 cm. Musée des
Beaux-Arts, Besançon

work for Catherine the Great he paid homage to another friend, the great sculptor Jean-Baptiste Pigalle (1714–85), by making his plaster *Mercury*, of which more than one version has survived, the centre of the composition. Catherine the Great already owned five paintings by Chardin and she was so pleased with the work when it arrived in St Petersburg that she kept it in her own private apartments.

In 1767 a tragic event occurred in Chardin's life. His son Jean-Pierre, who had trained to be a painter at the Academy and had won the First Prize for painting, committed suicide in Venice by drowning himself in a canal. He was travelling with the Marquis de Paulmy, the French Ambassador to Venice. By the beginning of the 1770s, Chardin was beginning to suffer from an eye affliction or paralysis which prevented him from continuing to paint in oils. This was caused by lead poisoning since the white pigment so frequently used by him, and indeed by all eighteenth-century painters, was lead based. Just as the famous Impressionist painter, Edgar Degas (1834–1917) abandoned oil painting for pastel a hundred years later, so too did Chardin. For this reason, from 1771 he exhibited at the Salon a number of pastel studies of heads. Some are studies from models such as the *Head of a Man* (Fig. 14); others are endearing portraits of children reminiscent of the work of two French painters of an earlier generation, Alexis Grimou (1678–1733) and Jean Raoux (1677–1734) and one is a copy after Rembrandt (Fig. 15). The most striking pastels however were his own self-portrait (Plate 47) and the *Portrait of Madame Chardin* (Fig. 39), his second wife, of which there are two versions, one in the Louvre and the other in the Art Institute of Chicago. These late works, tinged with melancholy, are moving images of the artist in old age.

From a professional point of view Chardin's last years were difficult. The Marquis de Marigny, who late in the artist's life had entrusted him with important royal commissions, was replaced as Surveyor General of the King's Buildings by the Comte d'Angiviller and Pierre became First Painter to the King. Pierre forced Chardin's friend Cochin to retire as Secretary of the Academy and in 1774 Chardin himself resigned as Treasurer and *tapissier* to the Salon. At the age of 80 Chardin died, perhaps fittingly, in his apartment in the Louvre.

Chardin left no pupils but many imitators. Artists such as Henri Roland de la Porte (1725–93) and Anne Vallayer Coster (1744–1818) owe much to Chardin. Fragonard was briefly apprenticed to him but he is remembered as the pupil of Boucher. Greuze had great success at the Salon with his genre paintings but they were narrative in content and moralizing in tone. In the year of Chardin's death, the young painter Jacques-Louis David (1748–1825), winner of the *Prix de Rome*, embarked on his Italian journey destined to turn the course of French painting for ever.

After his death Chardin was soon forgotten. It was not until the middle of the nineteenth century that he was rediscovered by art critics and artists to whom he became a cult figure. He inspired Édouard Manet (1832–83), Bonvin and the painters of the Realist school. In the twentieth century his greatest influence was undoubtedly on Cézanne. Perhaps the last word on Chardin should be left to Marcel Proust: 'If all this now strikes you as beautiful to the eye, it is because Chardin found it beautiful to paint; and he found it beautiful to paint because he thought it beautiful to the eye.'

Outline Biography

1699 Birth in Paris of Jean Siméon Chardin. He is baptized at Saint-Sulpice.

1723 Marriage contract between Chardin and Marguerite Saintard.

1724 Is received into the Academy of St Luke as a master painter after studying with Cazes and Noël-Nicolas Coypel.

1728 Exhibits *The Ray-Fish* (Plate 2) and *The Buffet* (Plate 4) at the Exposition de la Jeunesse. Admitted to and accepted by the Royal Academy.

1729 Firework display held at Versailles to celebrate the birth of the Dauphin, son of Louis XV. Chardin works on the scenery.

1731 Marries Marguerite Saintard at Saint-Sulpice. Birth and baptism of his son Jean-Pierre. Assists in restoration of frescos in the gallery of François I at Fontainebleau.

1733 Birth and baptism of his daughter Marguerite-Agnès.

1735 Death of Marguerite Saintard.

1736–7 Death of Marguerite-Agnès.

1737 Exhibits at the re-opened Salon.

1740 Is presented to Louis XV at Versailles and offers him *The Diligent Mother* (Plate 31) and *Saying Grace* (Plate 32), which are shown at the Salon the same year.

1743 Is elected Adviser to the Royal Academy.

1744 Marries Françoise-Marguerite Pouget at Saint-Sulpice.

1745 Birth of his daughter Angélique-Françoise, who dies six months later.

Chardin's works appear in a public sale in France for the first time – the sale of the estate of Antoine de la Roque.

1752 Louis XV acquires *The Bird-Song Organ* (Plate 34). Chardin receives his first royal pension.

1754 Jean-Pierre, the painter's son, wins the First Prize for painting at the Academy.

1755 Chardin is elected Treasurer of the Academy and is put in charge of the hanging of the Salon exhibition.

1757 Louis XV grants Chardin an apartment in the Louvre. Jean-Pierre Chardin receives a grant to study at the French Academy in Rome. Quarrel between Chardin and his son over Marguerite Saintard's will and inheritance.

1761 Has official charge of hanging the Salon exhibition.

1764 Receives royal commission for three overdoors at the château de Choisy.

1766 Receives royal commission for two overdoors at the château de Bellevue. Catherine the Great, commissions *The Attributes of the Arts and their Rewards* (Plate 45) for the Academy of Fine Arts in St Petersburg.

1767 Jean-Pierre Chardin arrives in Venice and is believed to have committed suicide between 1767 and 1769.

1774 Resigns as Treasurer of the Academy and is no longer in charge of hanging at the Salon.

1779 Dies on 6 December at nine in the morning in his apartment in the Louvre. He is buried at Saint-Germain l'Auxerrois.

Select Bibliography

Pierre-Jean Mariette, *Abécédario*, Vol. 1, 1749
 (published in *Archives de l'art français*,
 1853–62)

Charles-Nicolas Cochin, 'Essai sur la vie de
 Chardin', 1780 (published in *Précis
 analytique des travaux de l'Académie des
 Sciences, Belles-Lettres et Arts de Rouen*,
 1875–6)

Pierre Rosenberg, *Chardin*, Geneva, 1963

John Sunderland, *Chardin*, Bristol, 1963

Georges Wildenstein, *Chardin: Catalogue
 Raisonné*, Oxford, 1969

Pierre Rosenberg, *Chardin*, exhibition
 catalogue, Grand Palais, Paris; Museum of
 Art, Cleveland, OH; Museum of Fine
 Arts, Boston, MA, 1979

Gabriel P Weisberg and William S Talbot,
 *Chardin and the Still Life Tradition in
 France*, exhibition catalogue, Museum of
 Art, Cleveland, OH, 1979

Pierre Rosenberg, *Chardin: New Thoughts*, The
 Franklin D Murphy Lectures, Vol. 1,
 Lawrence, KS, 1983

Pierre Rosenberg, *Tout l'œuvre peint de Chardin*,
 Paris, 1983

Philip Conisbee, *Chardin*, Oxford, 1986

Marianne Roland-Michel, *Chardin*, Paris, 1994

List of Illustrations

Colour Plates

1 The Billiard Game
 c1721–5. Oil on canvas, 55 x 82.5 cm.
 Musée Carnavalet, Paris

2 The Ray-Fish
 1725–6. Oil on canvas, 114 x 146 cm.
 Musée du Louvre, Paris

3 Carafe, Silver Goblet and Fruit
 c1728. Oil on canvas, 55 x 46 cm.
 Staatliche Kunsthalle, Karlsruhe

4 The Buffet
 1728. Oil on canvas, 194 x 129 cm.
 Musée du Louvre, Paris

5 Wild Rabbit with Game-bag and Powder
 Flask
 1728–30. Oil on canvas, 81 x 65 cm.
 Musée du Louvre, Paris

6 A Green-neck Duck with a Seville
 Orange
 1728–30. Oil on canvas, 80.5 x 64.5 cm.
 Musée de la Chasse et de la Nature, Paris

7 The Attributes of the Sciences
 1731. Oil on canvas, 141 x 219.5 cm.
 Musée Jacquemart-André, Paris

8 The Fast Day Meal
 1731. Oil on copper, 33 x 41 cm.
 Musée du Louvre, Paris

9 Still Life with Herrings
 c1731. Oil on canvas, 32 x 39 cm.
 Ashmolean Museum, Oxford

10 Copper Cauldron with Three Eggs
 c1734. Oil on panel, 17 x 21 cm.
 Musée du Louvre, Paris

11 The Copper Water Urn
 c1734. Oil on panel, 28.5 x 23 cm.
 Musée du Louvre, Paris

12 Lady Sealing a Letter
 1733. Oil on canvas, 146 x 147 cm.
 Staatliche Museen Preussischer Kulturbesitz,
 Berlin

13 Woman at the Urn
 1733. Oil on panel, 38 x 43 cm.
 Nationalmuseum, Stockholm

14 The Laundress
 1733. Oil on canvas, 37.5 x 42.5 cm.
 Nationalmuseum, Stockholm

15 Soap Bubbles
 1733–5. Oil on canvas, 93 x 74.5 cm.
 National Gallery of Art, Washington, DC

16 Portrait of the Painter Joseph Aved
 1734. Oil on canvas, 138 x 105 cm.
 Musée du Louvre, Paris

17 Portrait of Charles Godefroy
 c1734–5. Oil on canvas, 67.5 x 74.5 cm.
 Musée du Louvre, Paris

18 Lady Taking Tea
 1735. Oil on canvas, 80 x 101 cm.
 Hunterian Art Gallery, University of Glasgow

19 The Embroiderer
 1735–6. Oil on panel, 18 x 15.5 cm.
 Nationalmuseum, Stockholm

20 Young Student Drawing
 1735–6. Oil on panel, 19.5 x 17.5 cm.
 Nationalmuseum, Stockholm

21 The Schoolmistress
 1735–6. Oil on canvas, 61.5 x 66.5 cm.
 National Gallery, London

22 The House of Cards
 1736–7. Oil on canvas, 60 x 72 cm.
 National Gallery, London

Text Illustrations

Comparative Figures

10 The Monkey as a Painter
 1735–40. Oil on canvas, 28.5 x 23.5 cm.
 Musée des Beaux-Arts, Chartres

11 JOSEPH AVED
 Portrait of Count Carl Gustav Tessin
 1740. Oil on canvas, 149 x 116 cm.
 Nationalmuseum, Stockholm

12 GABRIEL DE SAINT-AUBIN
 The Salon of 1765 at the Louvre
 1765. Black chalk, pen and ink and watercolour
 on paper, 24 x 46.7 cm.
 Cabinet des Dessins, Musée du Louvre, Paris

13 Autumn
 1770. Oil on canvas, 51 x 82.5 cm.
 Pushkin Museum of Fine Arts, Moscow

14 Head of a Man
 1773. Pastel on paper, 55 x 45 cm.
 Fogg Art Museum, Cambridge, MA

15 Head of an Old Woman
 1776. Pastel on paper, 46 x 38 cm.
 Musée des Beaux-Arts, Besançon

16 Manservant Pouring a Drink for a Player
 c1723. Sanguine, charcoal and white highlights on
 grey-brown paper, 24.8 x 36.7 cm.
 Nationalmuseum, Stockholm

17 JEAN-ÉTIENNE LIOTARD
 Princess Caroline-Louise of Hesse
 Darmstadt, Margravine of Baden
 1745. Pastel on paper, 59 x 49.5 cm.
 Staatliche Kunsthalle, Karlsruhe

18 Pewter Jug with a Tray of Peaches
 c1728. Oil on canvas, 55.5 x 46 cm.
 Staatliche Kunsthalle, Karlsruhe

19 The Spaniel
 c1728–30. Oil on canvas, 194.5 x 112 cm.
 Private collection

20 The Attributes of the Arts
 1731. Oil on canvas, 140 x 215 cm.
 Musée Jacquemart-André, Paris

21 The Feast Day Meal
 1731. Oil on copper, 33 x 41 cm.
 Musée du Louvre, Paris

22 Copper Cauldron with Pestle and Mortar
 c1734. Oil on panel, 17 x 20.5 cm.
 Musée Cognacq-Jay, Paris

23 The Game of Knucklebones
 1733–5. Oil on canvas, 81.5 x 64.5 cm.
 Museum of Art, Baltimore, MD

24 ÉDOUARD MANET
 Soap Bubbles
 1867. Oil on canvas, 100.5 x 81.4 cm.
 Calouste Gulbenkian Museum, Lisbon

25 JEAN-BAPTISTE MASSÉ
 The Godefroy Children
 1736. Red chalk on paper, 57 x 43 cm.
 Musée Nissim de Camondo, Paris

26 NICOLAES MAES
 Young Woman Sewing
 1655. Oil on panel, 54.2 x 44.5 cm.
 Private collection

1 The Billiard Game

*c*1721–5. Oil on canvas, 55 x 82.5 cm. Musée Carnavalet, Paris

Painted when the artist was in his twenties, this is his earliest surviving work. Billiard halls such as these were common in eighteenth-century Paris and the artist omits none of the incidental detail. On the right-hand wall the police regulations are posted up while the simple framework which hangs from the beamed ceiling shows the candles and metal reflectors which could light up the table for evening play. There is a preparatory drawing for the two figures on the extreme left of the composition (Fig. 16) which was purchased by the Swedish Ambassador to the French Court, Count Tessin, during his third posting there between 1739 and 1742. The composition of the painting is reminiscent of Watteau in the grouping of the elegant players and especially in the central foreground figure. The drawing is also influenced by him; it is executed in three coloured chalks – black, red and white – a technique in which Watteau excelled. Chardin may have painted this in homage to his father, a cabinet-maker who specialized in making billiard tables and who supplied the Royal Household and the organizers of the Royal Fêtes. Although Chardin began by painting genre scenes rather than still life, he did not return to this type of subject matter until the 1730s, when his friend, the painter Aved, persuaded him to take up figure painting again.

Fig. 16
Manservant Pouring a
Drink for a Player
*c*1723. Sanguine, charcoal
and white highlights on
grey-brown paper,
24.8 x 36.7 cm.
Nationalmuseum,
Stockholm

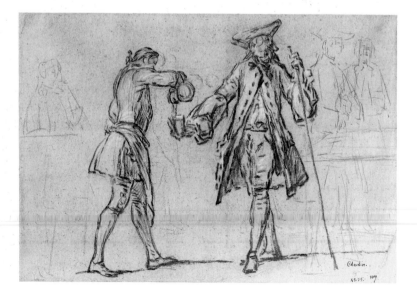

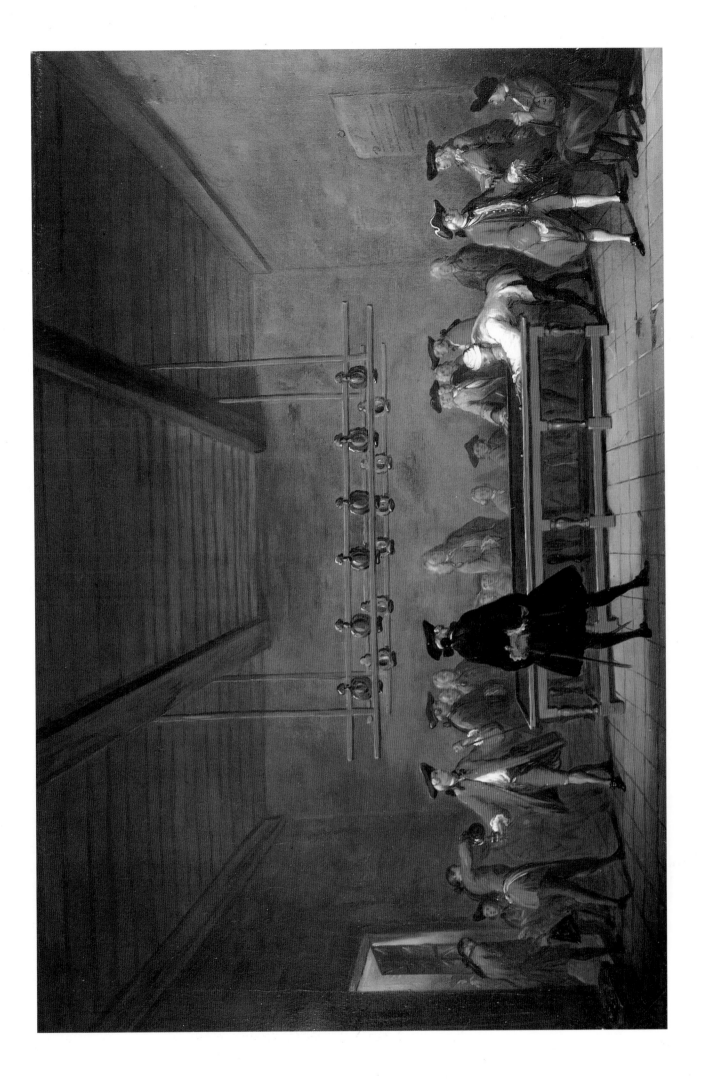

2 The Ray-Fish

1725–6. Oil on canvas, 114 x 146 cm. Musée du Louvre, Paris

Chardin exhibited this picture and *The Buffet* (Plate 4) at the Exposition de la Jeunesse in 1728, although he had painted it two to three years previously. On the advice of his fellow artists, Chardin submitted both paintings as his diploma works to the Academy in 1728. As a result of his submission, he was made Associate and Academician on the same day, an exceptional achievement for a painter who had not trained at the Academy and who was only 28.

This work owes more to seventeenth-century Dutch and Flemish still-life painting than to the French tradition. Indeed when the painter Nicolas de Largillière (1656–1746) saw Chardin's painting for the first time at the Academy, he believed it to be by a Flemish artist. The huge and hideous ray-fish looks more alive than dead as he grins menacingly out of the canvas. He presides over a chaos of kitchen pots and a crumpled tablecloth while a predatory cat claws its way towards the opened oysters. Dramatic in its realism, this work caused a sensation when first shown to the public in 1728.

In the twentieth century this work was copied by Cézanne and Henri Matisse (1869–1954) and clearly inspired the Lithuanian, Chaïm Soutine (1893–1943), when he painted *A Still Life with Skate* (Private collection).

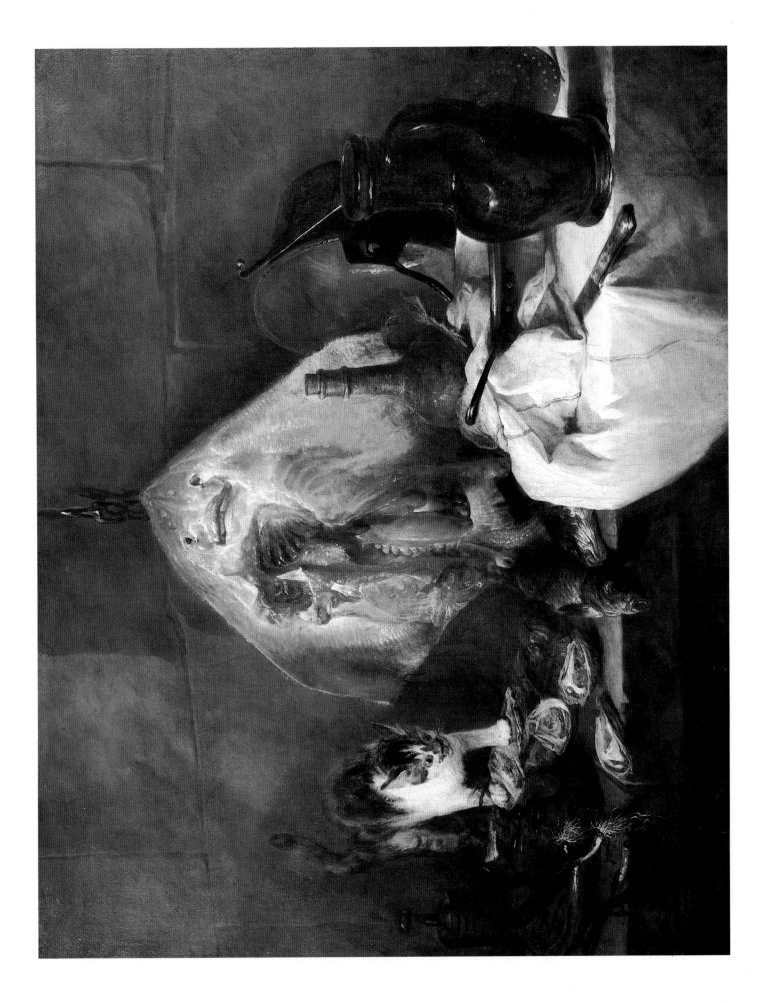

Carafe, Silver Goblet and Fruit

*c*1728. Oil on canvas, 55 x 46 cm. Staatliche Kunsthalle, Karlsruhe

Fig. 17
JEAN-ÉTIENNE
LIOTARD
Princess Caroline-
Louise of Hesse
Darmstadt,
Margravine of Baden
1745. Pastel on paper,
59 x 49.5 cm.
Staatliche Kunsthalle,
Karlsruhe

Fig. 18
Pewter Jug with a
Tray of Peaches
*c*1728. Oil on canvas,
55.5 x 46 cm.
Staatliche Kunsthalle,
Karlsruhe

In 1761 Princess Caroline-Louise of Hesse Darmstadt, Margravine of Baden (Fig. 17), an important collector of contemporary French painting, acquired this painting from Chardin's friend, the painter Aved. She also bought *Pewter Jug with a Tray of Peaches* (Fig. 18) which was designed to hang with the *Carafe, Silver Goblet and Fruit*. She had already purchased two of Chardin's still lifes in 1759 and specifically travelled to Paris in 1771 in order to meet the artist in person. The silver goblet is one of two cited in the inventory of Marguerite Saintard, Chardin's first wife, and it appears in a number of his still lifes throughout his career. Chardin used elements from both these works – the carafe, the pewter jug and the half-peeled lemon – in *The Buffet* (Plate 4) which he submitted to the Academy in 1728 as his diploma work. The brilliant painting of the fruit reflected in the carafe, combined with the extreme simplicity of the composition, make this one of the most successful of Chardin's early works.

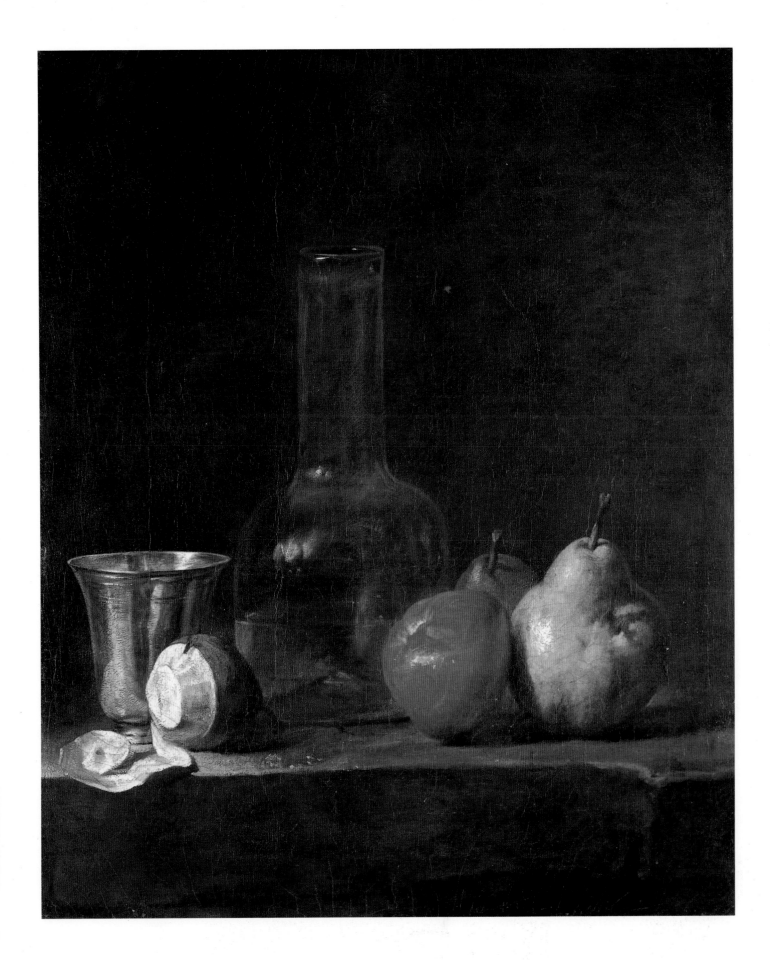

4 The Buffet

1728. Oil on canvas, 194 x 129 cm. Musée du Louvre, Paris

The Buffet and *The Ray-Fish* (Plate 2) were the two diploma works that Chardin presented to the Academy in 1728. Although today *The Ray-Fish* is the more famous picture, *The Buffet* is the larger and more ambitious composition. While the former is inspired by Dutch and Flemish prototypes, *The Buffet* reveals the influence of Chardin's contemporary, Desportes, who made a speciality of these elegant buffets. Frequently illusionistic, they were intended to be inset in the panelling of a dining room above a real table set with food and silver. Chardin's painting, however, does not have the theatricality of Desportes's still lifes which were sumptuous productions made for Louis XIV and members of the Court. The objects in Chardin's paintings are simple – glass carafes, a pewter jug and a tray of oysters. It was this quest for simplicity which was to lead Chardin to transform the painting of still life from mere decoration into a new genre with its own poetry and symbolism.

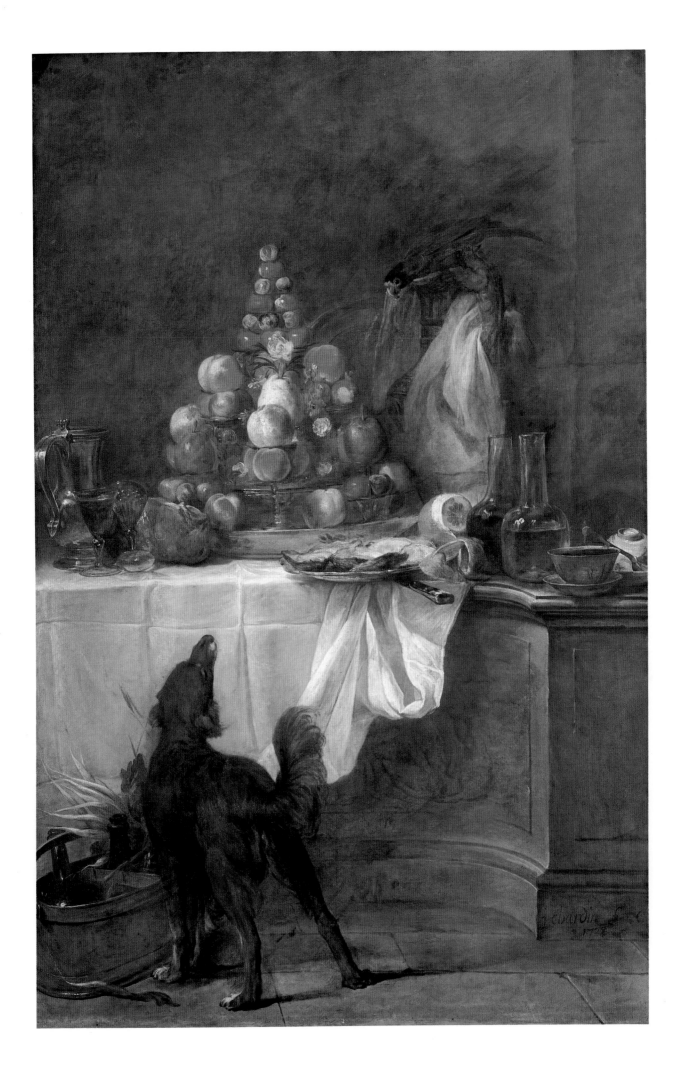

Wild Rabbit with Game-bag and Powder Flask

1728–30. Oil on canvas, 81 x 65 cm. Musée du Louvre, Paris

Chardin found the subject matter for his early still lifes in dead game, hares and wild rabbits. His originality lay in the truth of his observation and the freedom with which he handled his paint. His compositions, whether of a single bird or animal, are deceptively simple, revealing none of the artifice or search for a decorative effect which was such a feature of the Rococo.

This moving work is one of a group of single dead hares or rabbits which Chardin painted around 1728–30. They nearly always include hunting accoutrements – guns, game-bags and powder flasks – and are tender images of these victims of the sport, which was the favourite pursuit of both Louis XIV and XV and the French aristocracy.

Many of Chardin's early works were bought by friends and fellow artists. This painting belonged to the famous sculptor Caffiéri and in the nineteenth century to the Neo-classical painter Jules Boilly (1796–1874). When acquired by the Louvre in 1852 it inspired a number of nineteenth-century avant-garde artists including Manet.

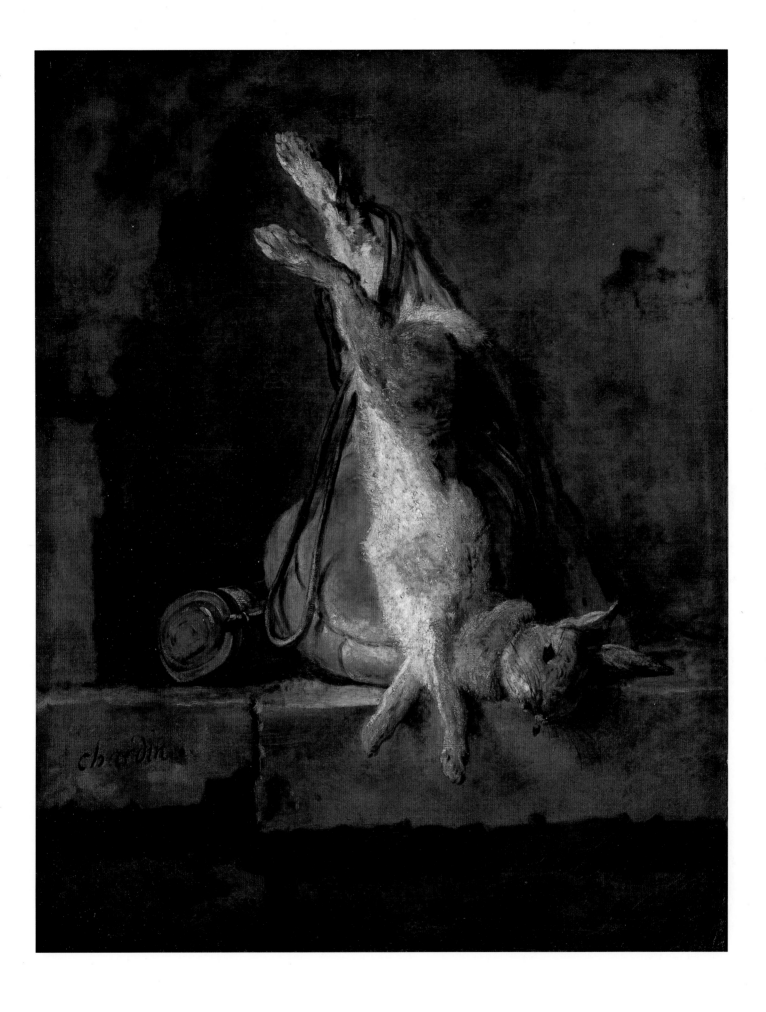

A Green-neck Duck with a Seville Orange

1728–30. Oil on canvas, 80.5 x 64.5 cm. Musée de la Chasse et de la Nature, Paris

Fig. 19
The Spaniel
*c*1728–30. Oil on canvas,
194.5 x 112 cm.
Private collection

Dead game – ducks, hares, pheasant and partridges – formed the subject matter of much of Chardin's youthful work. This painting is a study in the contrasts of colour and texture, the orange of the duck's feet and bill contrasting with the grey-brown of its soft plumage, the granular texture of the fruit contrasting with that of the dull stone ledge. It recalls the early still lifes of Oudry, Chardin's exact contemporary who, with Desportes, was one of the two most successful practitioners of the still-life genre in eighteenth-century France. Oudry's still lifes, however, are brilliant exercises in *trompe-l'œil* rather than attempts at naturalistic painting, and are always elegantly composed.

The duck reappears in 1730 in *The Spaniel* (Fig. 19) although it is not necessarily a study for this painting. The artist Jean-Jacques Bachelier (1724–1806) may have had Chardin's works in mind when he painted his *Duck Hanging on a Pine Plank* (Musée des Beaux-Arts, Angers) in 1753, although it owes more to Oudry than to Chardin's realism.

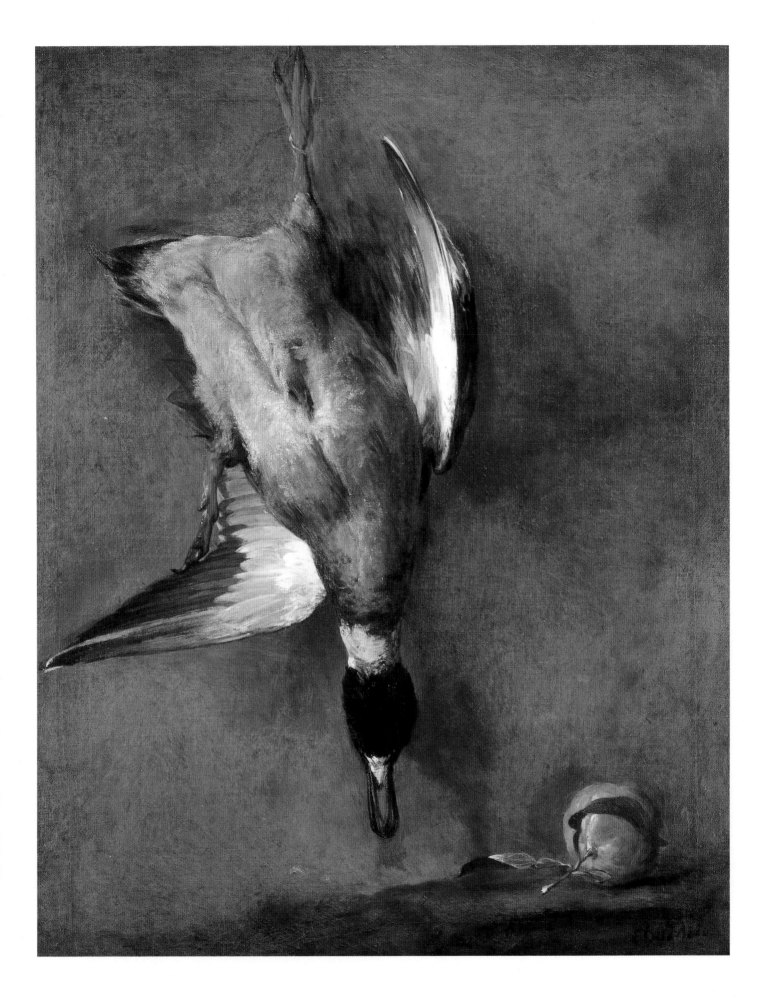

The Attributes of the Sciences

1731. Oil on canvas, 141 x 219.5 cm. Musée Jacquemart-André, Paris

Chardin's first important patron, the Count de Rothenbourg, French Ambassador to the Court of Spain, commissioned this painting together with *The Attributes of the Arts* (Fig. 20). The Count was the son of a Russian nobleman and after a brilliant military career he entered the diplomatic service. He had refurbished his house in Paris at 5, rue du Regard on the Left Bank at great expense and in 1730 commissioned from Chardin three paintings of musical subjects, designed to go over the doors in the salon. A year later he asked Chardin for two large paintings for the library to be displayed above the cabinets. It is clear from the compositions that the two paintings balance and that they were intended to be seen from below.

The objects in this canvas – a huge globe, maps, a telescope, a set square, a sextant, a Turkish carpet and an incense burner – are as much reminders of the Ambassador's travels in distant lands as symbols of the sciences. It has been pointed out that the globe was directly inspired by one of the terrestrial globes engraved in 1696 by Vincenzo Coronelli.

Fig. 20
The Attributes of
the Arts
1731. Oil on canvas,
140 x 215 cm.
Musée Jacquemart-André,
Paris

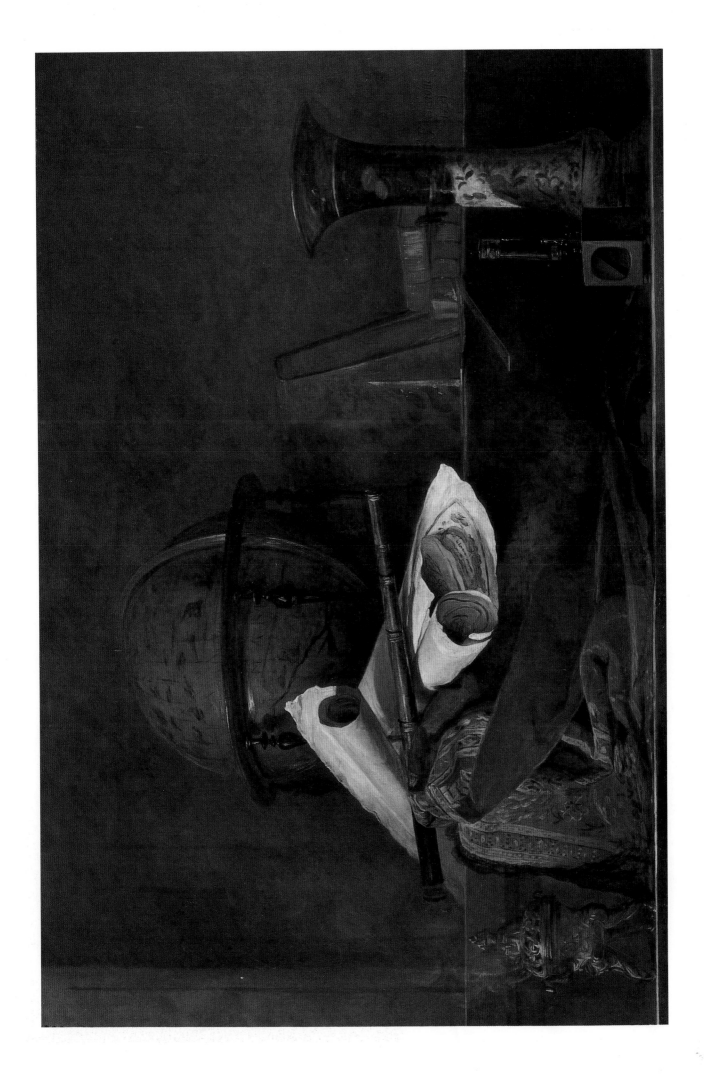

The Fast Day Meal

1731. Oil on copper, 33 x 41 cm. Musée du Louvre, Paris

The Fast Day Meal and *The Feast Day Meal* (Fig. 21) were designed as a pair. They were given their titles in the nineteenth century and refer to the Lenten fast. Their history is unknown prior to 1840 when they were discovered and purchased for ten francs by the collector and critic Théophile Thoré who was responsible for the re-evaluation of Chardin's work. In 1852 they were acquired by the Louvre. The Curator of Paintings wrote of them as follows: 'Chardin's paintings on copper are extremely rare; and these in particular, combining as they do a very fine finish of a thick, bold touch, prove that the French school has had artists who were equal to if not better than the most skilful Flemish painters.'

Painted in 1731, the year of his long-awaited marriage to Marguerite Saintard, this work and *The Feast Day Meal* are the most complex and ambitious of his early kitchen still lifes. At this time, Chardin abandoned the painting of dead game and fruit and concentrated instead on depicting the plainest of kitchen utensils – a saucepan, jug, grill and ladle – and the simplest of food – fish, eggs and vegetables. Both works are painted on copper, a support Chardin rarely used but which was common among seventeenth-century Dutch still-life painters and which gives their surfaces a lustrous sheen. There is a deliberate contrast between the colours and tonality of the two works. The cold, metallic greys of the fish and frying pan of *The Fast Day Meal* contrast with the warm reds and browns of the meat and copper pan in *The Feast Day Meal*. As is usual with Chardin, the composition and arrangement of the objects is complex but at the same time deceptively simple.

Fig. 21
The Feast Day Meal
1731. Oil on copper,
33 x 41 cm.
Musée du Louvre, Paris

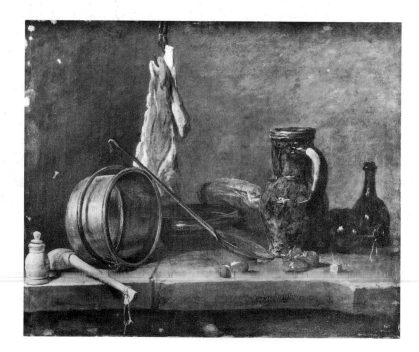

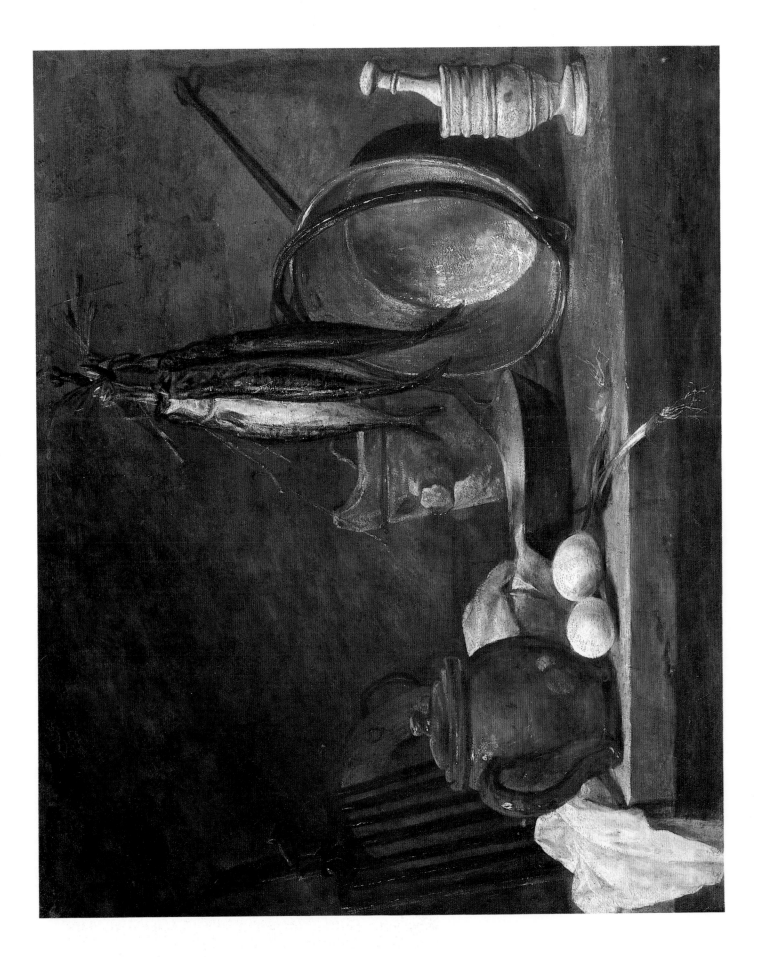

9 Still Life with Herrings

*c*1731. Oil on canvas, 32 x 39 cm. Ashmolean Museum, Oxford

Similar in date and style to *The Fast Day Meal* (Plate 8) and *The Feast Day Meal* (Fig. 21), this work contains elements found in both these compositions. The copper pan, jug, eggs and herrings are all repeated here and indeed in many of the small kitchen still lifes of this period. All are variations on a theme. This painting is essentially a study in cylindrical forms. The wall and ledge are curved, the jug and pitcher are rounded, the casserole and copper pan have circular forms, the eggs are ovoid. In terms of colour, the white of the eggs, the pink of the salmon and the silver-grey of the herrings punctuate the dark and sombre tones of the jug, copper pan and pitcher. The result is a painting which is perfectly balanced and constructed, but at the same time appealing in its humility. As the writers Jules and Edmond de Goncourt wrote of the artist in 1863: 'Nothing is too humble for his brushes. He dwells on the larder of the common man.'

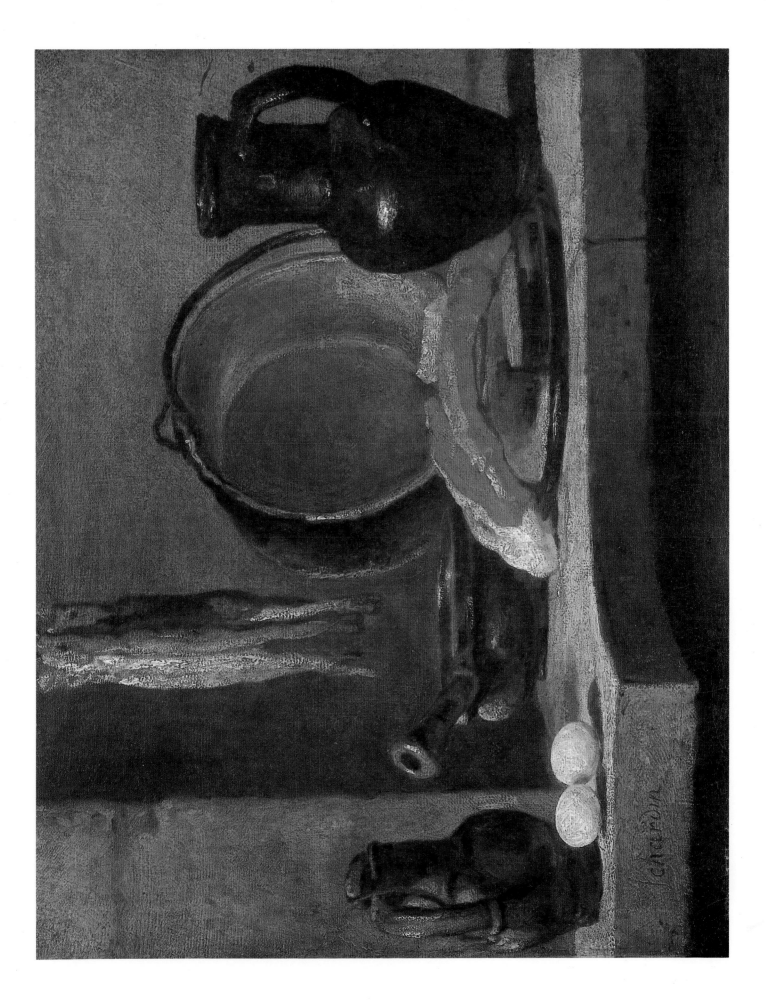

Copper Cauldron with Three Eggs

*c*1734. Oil on panel, 17 x 21 cm. Musée du Louvre, Paris

Up to the middle of the 1730s Chardin continued his experiments with painting small kitchen still lifes, undoubtedly because he could find a serious market for them among Parisian collectors. The summit of his achievement in this genre is the work illustrated here and *Copper Cauldron with Pestle and Mortar* (Fig. 22), painted to hang next to it. These works may be two of the three listed in the posthumous inventory of Chardin's first wife in 1737 and they may also have belonged to Chevalier Antoine de la Roque, editor of the *Mercure de France* and Chardin's early champion. La Roque gave glowing reviews of Chardin's paintings when the artist was relatively unknown and was first exhibiting at the Exposition de la Jeunesse in the late 1720s.

In both paintings, Chardin has reduced the number of his kitchen utensils to a minimum. The objects are carefully arranged on a stone ledge on which the artist has seemingly scratched his signature. The copper cauldron appears in both paintings, in the first upright, in the second lying on its side. The pepper mill is balanced by the pestle and mortar, the earthenware casserole by the bowl and the three eggs by the two onions. In both compositions, Chardin breaks the hard line of the stone ledge, with a spring onion in one and a knife in the other. Both paintings are perfectly balanced within themselves and with one another. The effect of such perfection, however, is not one of calculated artistry but rather of images that inspire reflection and contemplation.

Fig. 22
Copper Cauldron with
Pestle and Mortar
*c*1734. Oil on panel,
17 x 20.5 cm.
Musée Cognacq-Jay, Paris

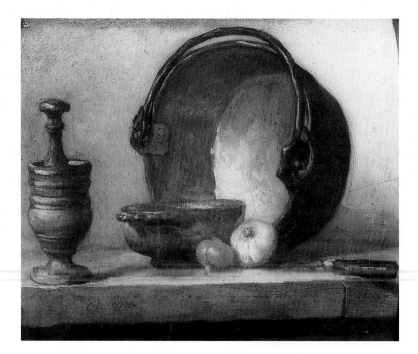

The Copper Water Urn

*c*1734. Oil on panel, 28.5 x 23 cm. Musée du Louvre, Paris

'And so, with his infinite simplicity, Chardin gains our confidence, we will trust him anywhere; we know he will not try to impress us.' So wrote the twentieth-century critic Roger Fry, and he could well have been talking about this painting, since here Chardin makes one simple household object the entire subject of his composition. Depicted in stark simplicity against a bare background of cold, grey stone, it fills the centre of the panel. Chardin loved to paint stone walls as backdrops to his still lifes. Here it sets off brilliantly the warm, gleaming copper of the urn which stands out in bold relief. The water urn formed an essential part of the eighteenth-century household and this particular one is described in detail in the posthumous inventory of Chardin's first wife. Made of red copper with a copper cover and rings fitting onto a Chinese wooden stand, it was highly valued at 25 livres. Chardin used the urn again in two of his most famous paintings, the *Woman at the Urn* (Plate 13) and *The Return from Market* (Plate 29) where it is seen in the background through an open door. It is not, however, a preliminary study for either of these paintings, but a work of art in its own right. Described as one of Chardin's most perfect compositions because of its bold simplicity and omission of superfluous detail, it was a major source of inspiration to the French Realist artist Bonvin. Bonvin painted his *Copper Urn* (Walters Art Gallery, Baltimore, MD) in 1861, probably having seen Chardin's painting when it was exhibited in Paris at the Galerie Martinet in 1860, or when it belonged to Louis la Caze, one of the most important nineteenth-century collectors of Chardin's work. La Caze donated 11 of Chardin's paintings to the Louvre in 1869.

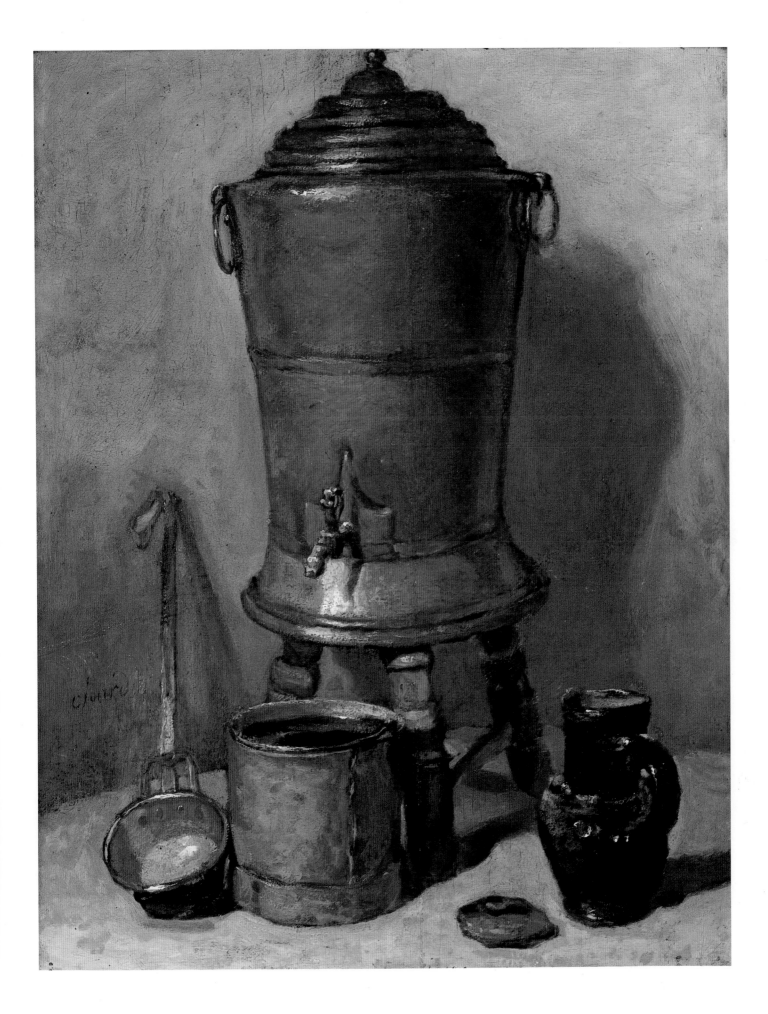

Lady Sealing a Letter

1733. Oil on canvas, 146 x 147 cm. Staatliche Museen Preussischer Kulturbesitz, Berlin

Chardin showed this work first at the Exposition de la Jeunesse in 1734 and again in 1738 at the Salon when exhibitions resumed there. He was praised by the critics for the realism of his figures since up to that time he had been known only as a still-life painter. The subject matter, the reading, writing or sending of love letters, derives from Dutch seventeenth-century painting and is a common theme in the works of Ter Borch and Godfried Schalcken (1643–1703). It is also close to the amorous subjects of two of Chardin's contemporaries, Watteau and De Troy. Chardin's paintings have much in common with De Troy's paintings of *The Declaration of Love* and *The Garter* (both in the Wrightsman Collection in the Metropolitan Museum of Art, New York) which he had shown at the Salon of 1725. The richly furnished interior is unusual in Chardin's *œuvre*. In his later figure paintings he preferred more humble or more neutral backgrounds. The lady is richly attired in striped silk and her eagerness in sending her lover a letter is symbolized by the greyhound at her knee, the dog also being a symbol of fidelity. Although there is a certain awkwardness in the female figure which the artist has been unable to resolve, we remain entranced by the soft and tender expression on her face and the concentration in her servant's eyes. The painting was engraved by Étienne Fessard (1714–77) in 1738 after it was shown at the Salon with the following amusing verse:

O hurry up Frontain; look at your young mistress, with tender impatience lighting her eyes.
She is already longing that the object of her desires should have received this note, measure of her affections.
Ah Frontain, to be as slow as this, the god of love has never touched your heart.

This work was acquired in the eighteenth century by Prince Henry of Prussia, brother of Frederick the Great, for the Unter den Linden Palace in Berlin. He may have purchased it as early as 1738.

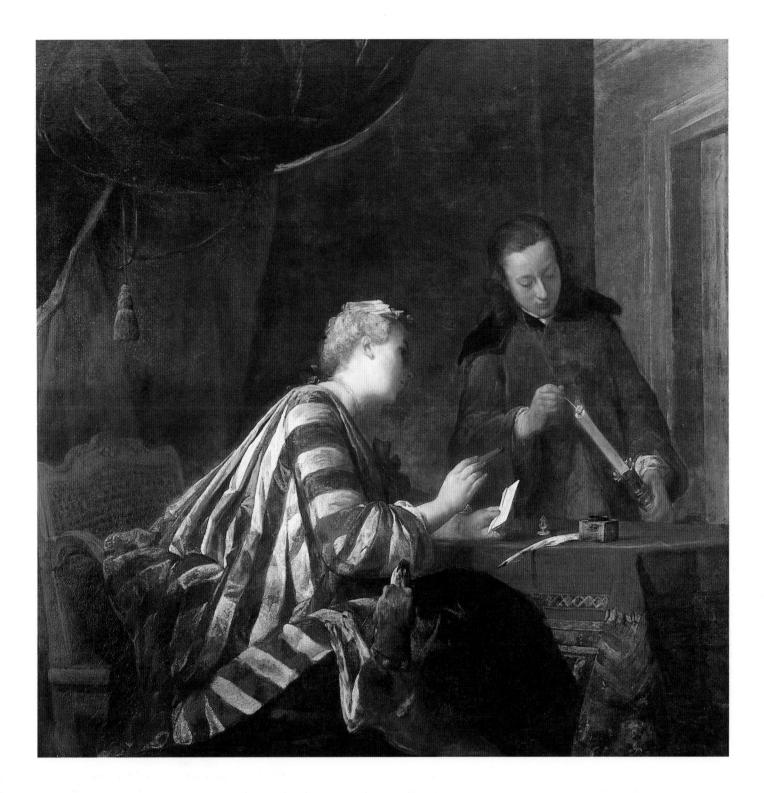

13 Woman at the Urn

1733. Oil on panel, 38 x 43 cm. Nationalmuseum, Stockholm

Woman at the Urn and *The Laundress* (Plate 14) were designed to hang side by side and were both made for La Roque, whose posthumous sale of 1745 included ten of the artist's paintings. *Woman at the Urn* and *The Laundress* were acquired at the La Roque sale by Count Tessin on behalf of the Swedish royal family. Both works were exhibited at the Salon of 1737 and engraved in 1739 by Cochin. This painting and *The Laundress* are two of Chardin's early experiments in genre painting after he had abandoned still life in the early 1730s. Elements from the still lifes remain, however, and recognizable objects such as the large copper pan, green glazed jug and frying pan reappear. Inspired by such Dutch seventeenth-century artists as Nicolaes Maes (1634–93) or Pieter Gerritz van Roestraten (*c*1632–1700), Chardin's paintings were described by critics as being in the style of Teniers. This was high praise indeed, since Teniers was the most popular and valued Dutch artist in eighteenth-century France. In this painting, Chardin has made the copper urn, which he had used as the subject for a still life (Plate 11), the central motif of the composition. The female figure is entirely static as are all three figures in the painting. Although occupied, they seem both conscious and unconscious of each other and their half-concealed faces are inexpressive. Silence and mystery characterize these early works; this was to become a feature of the artist's entire *œuvre*.

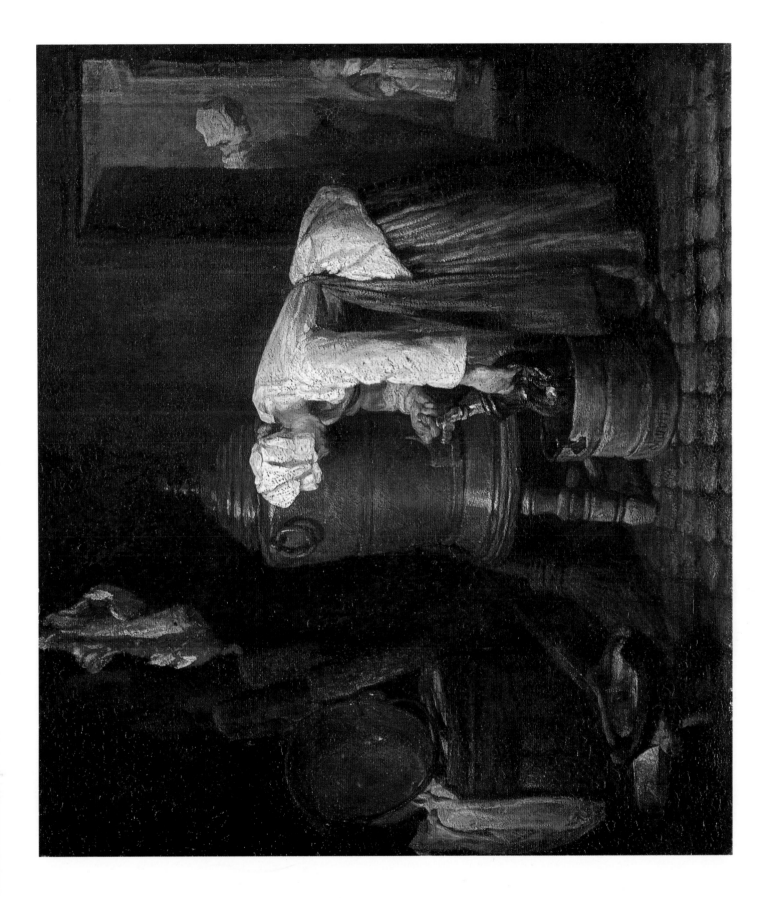

14 The Laundress

1733. Oil on canvas, 37.5 x 42.5 cm. Nationalmuseum, Stockholm

This work was painted to accompany *Woman at the Urn* (Plate 13) although unlike the latter it is painted on canvas not panel. Both works were described as being in the Dutch taste when they were first exhibited in 1734. The child at the laundress's feet is typically Dutch in inspiration, as he blows a soap bubble, a symbol of time's evanescence. The cat crouching in the corner also features in Dutch painting, as does the door opening from a darkened room into an area of light – a motif of which Chardin was particularly fond. In his early genre paintings Chardin always portrays women at work. They look out at us surprised, as if suddenly disturbed by the artist's presence.

Chardin did another version of this painting which belonged to the eighteenth-century collector Louis-Antoine Crozat (1699–1770). It was acquired along with the major part of the Crozat collection by Catherine the Great and is now in the Hermitage Museum, St Petersburg.

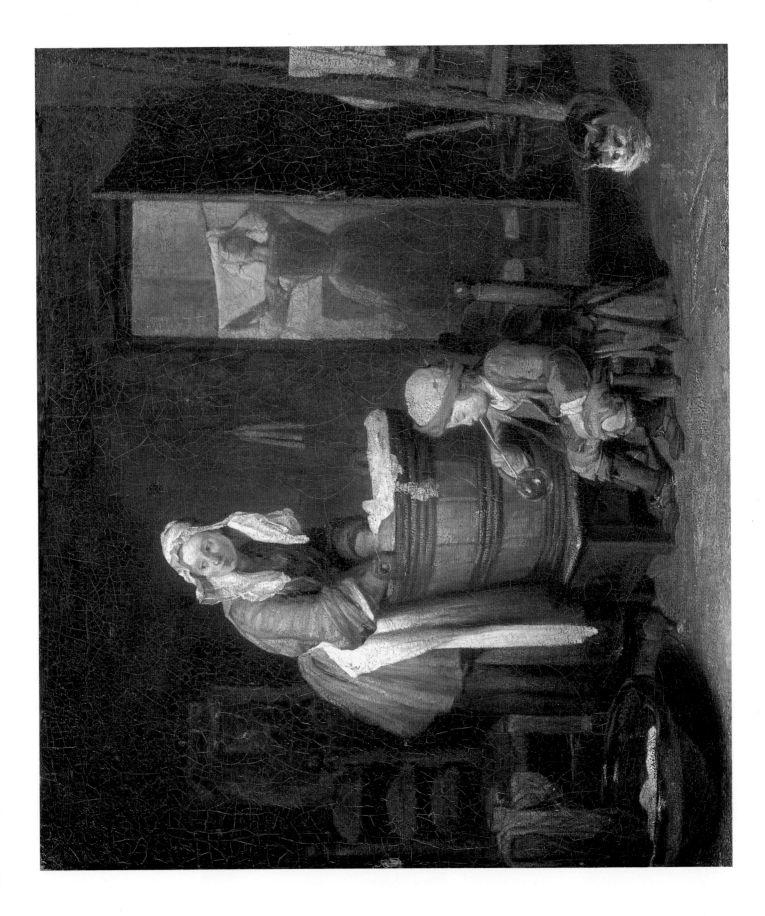

Soap Bubbles

1733–5. Oil on canvas, 93 x 74.5 cm. National Gallery of Art, Washington, DC

Fig. 23
The Game of
Knucklebones
1733–5. Oil on canvas,
81.5 x 64.5 cm.
Museum of Art, Baltimore,
MD

Fig. 24
ÉDOUARD MANET
Soap Bubbles
1867. Oil on canvas,
100.5 x 81.4 cm.
Calouste Gulbenkian
Museum, Lisbon

This is probably one of Chardin's first experiments in genre painting. The symbolism of the subject matter – the transience of human life – has a long iconographical tradition going back to the sixteenth century. It was frequently treated by Dutch seventeenth-century painters in whose work Chardin found so much of his inspiration. Chardin has also used the typically Dutch motif of a window to frame his composition, a device often used by painters such as Dou whose work was extremely popular in eighteenth-century France. Chardin did several versions of this painting, one of which was exhibited at the Salon of 1739 and engraved by Pierre Fillœul (1696–after 1754). It is possible that Chardin's painting of a young girl at play, *The Game of Knucklebones* (Fig. 23) was painted to go with it. In *Soap Bubbles* Chardin treats the theme of youth or adolescence for the first time and focuses on the concentration of the boy on his game. One of the best descriptions of this work is that written in the French periodical *The Artist* in 1845:

> Nothing could be more natural, more graceful, or more harmonious than this charming composition. It is nature caught in the act, without dazzling colour or the least affectation. You have seen this young boy twenty times, a hundred times … he reminds you nostalgically of the simple games of your own childhood.

Manet paid homage to Chardin when he painted *Soap Bubbles* (Fig. 24), perhaps having seen Chardin's picture in Paris at the Galerie Martinet in 1860 or at the Laperlier sale in April 1867.

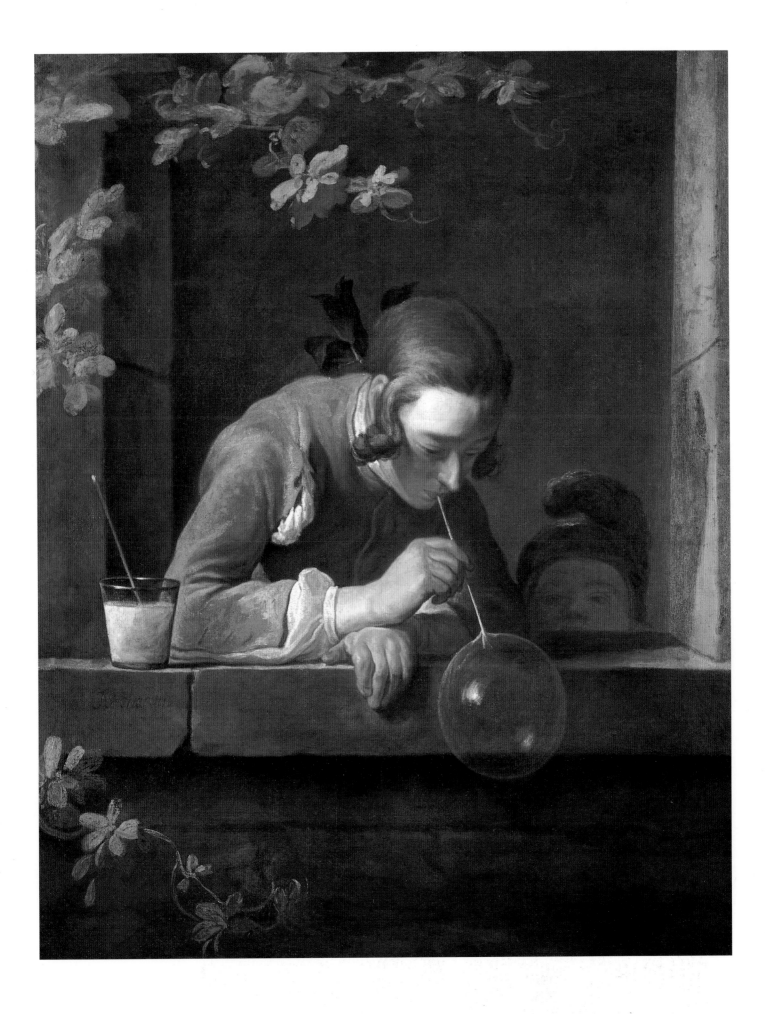

16 Portrait of the Painter Joseph Aved

1734. Oil on canvas, 138 x 105 cm. Musée du Louvre, Paris

In the eighteenth century this portrait of Chardin's close friend and fellow painter, Aved, was also given the title of 'The Philosopher' and 'The Alchemist'. It was painted for Count de Rothenbourg who had commissioned from Chardin *The Attributes of the Arts* (Fig. 20) and *The Attributes of the Sciences* (Plate 7) in 1730. The Count died in 1735, a few months after this work was completed, and it was subsequently returned to the artist.

Aved was one of Chardin's oldest friends and it was he who had encouraged him to devote himself to genre painting in the 1730s. This portrait was clearly painted in homage to him. He was a witness at Chardin's second marriage to Françoise-Marguerite Pouget in 1744 and the posthumous sale of his collection in 1766 contained nine paintings by Chardin. In the second half of the eighteenth century, critics compared Chardin's portrait of Aved to portraits by Rembrandt (1606–69). Chardin may have chosen to depict Aved in Rembrandtesque costume because his nickname was 'Le Batave', (the 'Batavian' or 'Dutchman'); Aved had originally trained as a painter in Amsterdam. The critics also praised the meditative aspect of the sitter who is portrayed not merely reading but absorbed in thought and contemplation. The notion of the transience of life is never absent from Chardin's early painting and in this work the hourglass, pen and learned volumes symbolize the futility of study and research.

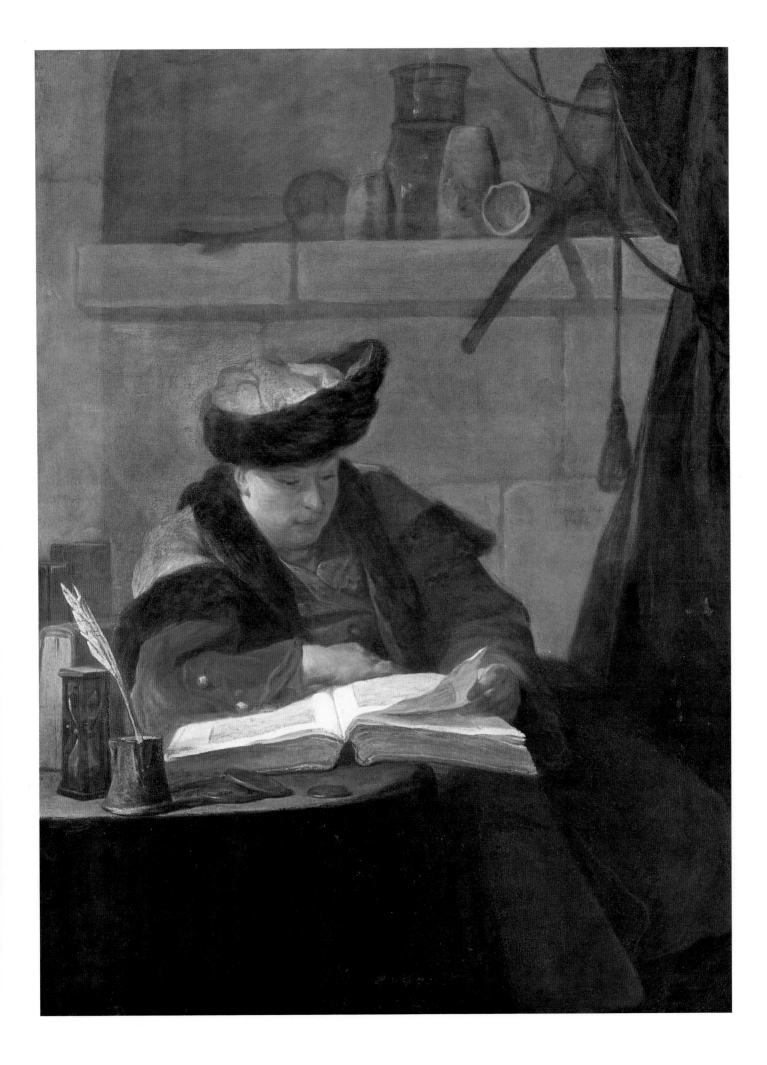

Portrait of Charles Godefroy

*c*1734–5. Oil on canvas, 67.5 x 74.5 cm. Musée du Louvre, Paris

Fig. 25
Jean-Baptiste Massé
The Godefroy
Children
1736. Red chalk on paper,
57 x 43 cm.
Musée Nissim de
Camondo, Paris

The sitter's father, a Parisian banker and jeweller and a close friend of Chardin, commissioned this elegant portrait from him. The artist also painted the portrait of his younger brother, Auguste Gabriel (Plate 25), who was ten years his junior, although the two portraits were not painted as a pair. A drawing by Chardin's contemporary, the French painter Jean-Baptiste Massé (1687–1767), entitled *The Godefroy Children* (Fig. 25) shows the two brothers with a family friend seated in an elegant library or study.

Charles Godefroy, who is aged about 17 in this portrait, was a serious musician and friend of the famous composer of comic opera, André Grétry (1741–1813). Later in life he became a keen patron of the arts. Portraits are rare in Chardin's *œuvre* and not always successful. In this painting, however, the sitter looks composed and his expression is serious and direct. The whole atmosphere of the portrait is one of refinement and sensitivity.

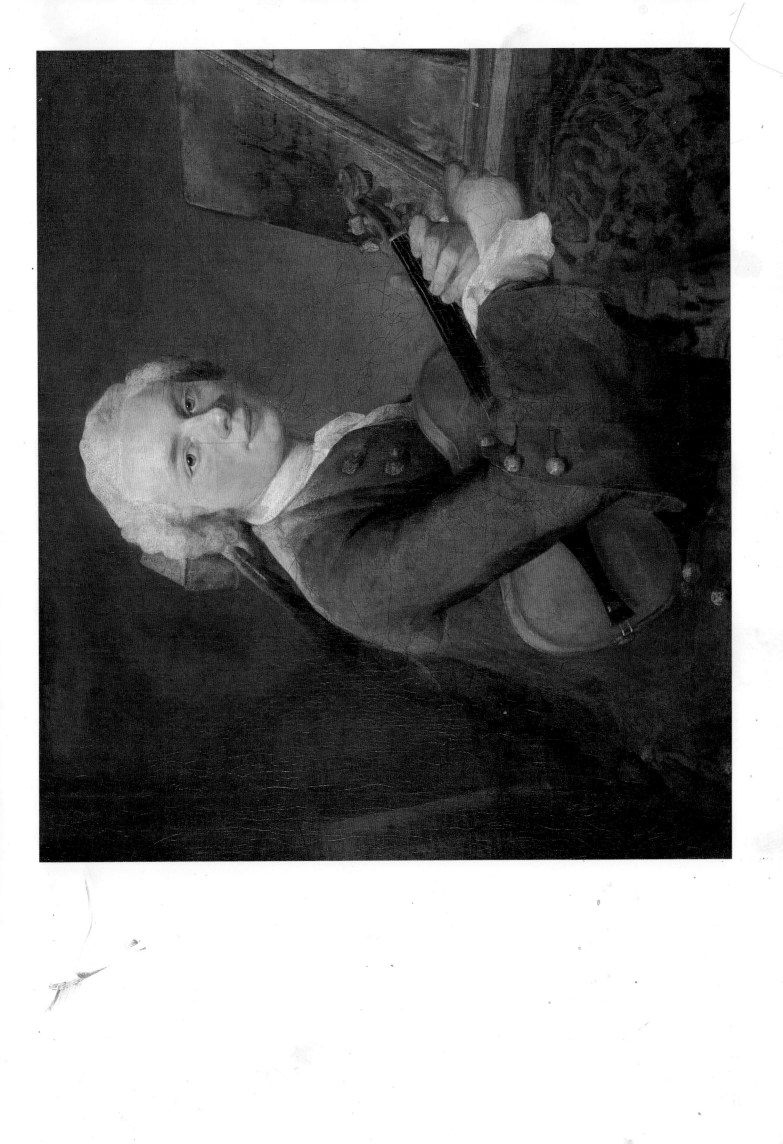

Lady Taking Tea

1735. Oil on canvas, 80 x 101 cm. Hunterian Art Gallery, University of Glasgow

The model in this painting and in the *Lady Sealing a Letter* (Plate 12) are both depicted wearing the same striped silk dress. Their hairstyles and round soft-featured faces are alike. It is believed they both represent the artist's first wife, Marguerite Saintard, who died in April 1735. If this hypothesis is correct, this touching portrait of her would have been painted two months before she died, since inscribed on the back of the canvas is the date 'fevrier 1735'. In addition the red serving table and the earthenware teapot are described as being in Madame Chardin's bedroom in her posthumous inventory of 1737.

This work is similar in style and date to the portrait of Aved (Plate 16) where the large single figure dominates the canvas. Here the background is left empty and bare so that the spectator feels he can enter the room where the solitary female figure dreamily stirs her tea. Tenderness and melancholy emanate from this painting.

This work was purchased in London in 1765 by the Scottish physician, Dr William Hunter, alumnus of the University of Glasgow and founder of the university's museum which bears his name. The sale also contained a version of *The House of Cards* (Private collection), which Chardin painted to accompany the *Lady Taking Tea*. Hunter's collection ranged from books on science and medicine to coins and works of art. He owned two other paintings by Chardin, *The Scullery Maid* (Plate 28) and *The Cellar Boy* (Fig. 29). His portrait was painted by the Scottish artist Allan Ramsay (1713–84) (Fig. 9).

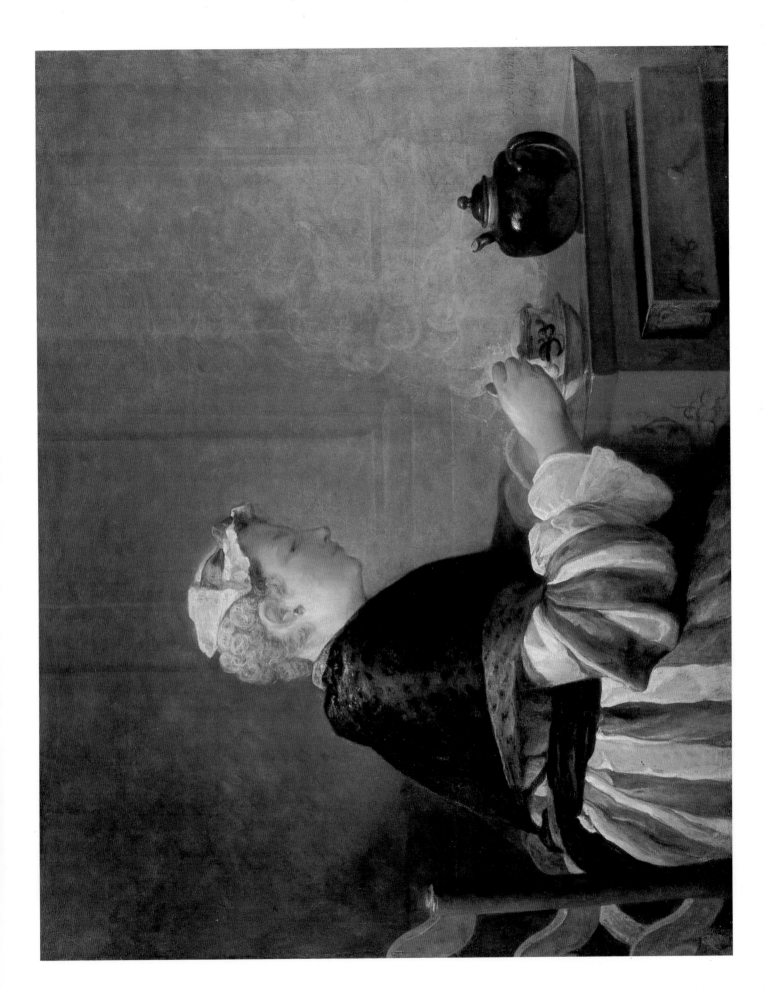

1735–6. Oil on panel, 18 x 15.5 cm. Nationalmuseum, Stockholm

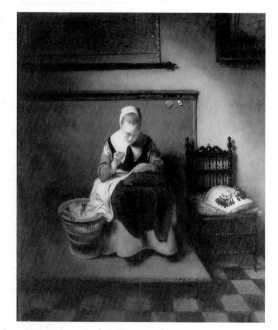

Fig. 26
NICOLAES MAES
Young Woman
Sewing
1655. Oil on panel,
54.2 x 44.5 cm.
Private collection

This tiny painting and its companion piece the *Young Student Drawing* (Plate 20) may have been commissioned by La Roque at whose posthumous sale in 1745 they were acquired by the dealer Gersaint for Prince Adolf Frederick of Sweden. Although exhibited at the Salon of 1738, both works were probably painted two to three years previously. The subject of *The Embroiderer* is influenced by Dutch seventeenth-century painting, recalling the work of Maes although the elegance of the female figure makes it a very eighteenth-century image. One of Maes's paintings of a *Young Woman Sewing* (Fig. 26) was in the collection of the Comte de Vence in Chardin's day. He was one of the most important French collectors of Dutch seventeenth-century painting at the time.

Sitting alone in her workroom, the embroiderer is portrayed with a dreamy expression as she bends to choose a ball of blue wool from her work basket. The basket, the ell (a cloth measure) and the pincushion form a separate still life within the picture. The contrast between the striking black and white of the embroiderer's dress and cap and the soft beiges of the workroom floor and basket make this one of Chardin's most beautiful early works. In addition to Dutch prototypes, Chardin may also have been inspired by a contemporary engraving after Watteau, *Occupation According to Age*, which shows a similar female figure sitting with downcast eyes, intent on her sewing. The French twentieth-century art historian, Elie Faure, drew a parallel between Watteau and Chardin:

[Chardin] knows ... that the life of the objects depends on the moral life of human beings, that the moral life of human beings receives the reflections of these objects. He pays his tender respect to all that exists. He and Watteau are, in France, the only pious painters of an impious century.

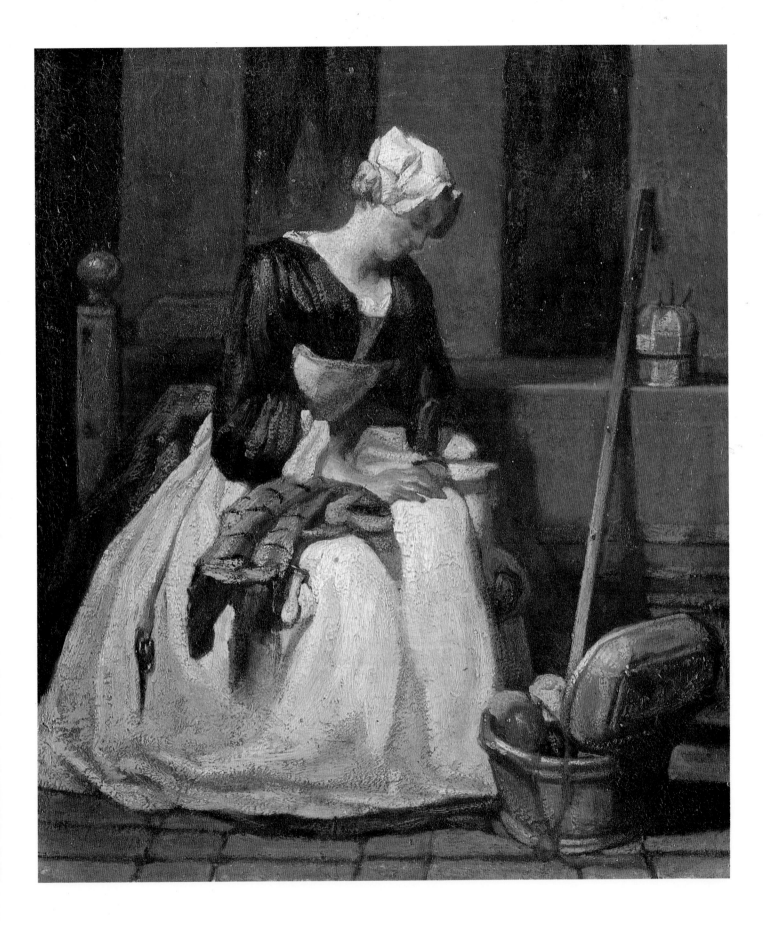

1735–6. Oil on panel, 19.5 x 17.5 cm. Nationalmuseum, Stockholm

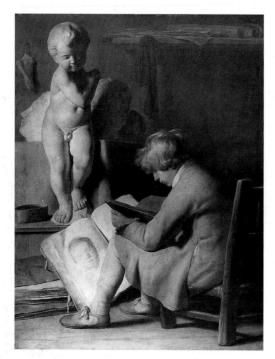

Fig. 27
WALLERANT
VAILLANT
The Young
Draughtsman
1656–9. Oil on canvas,
129 x 100 cm.
Musée du Louvre, Paris

Both this painting and *The Embroiderer* (Plate 19) originally existed in at least five versions, testifying to their popularity in Chardin's lifetime. The subject of the young artist drawing is commonly found in Dutch seventeenth-century painting and a source for Chardin's picture might have been in works by the Flemish painter Wallerant Vaillant (1623–77), who was in Paris between 1659 and 1665. His painting of *The Young Draughtsman* (Fig. 27) is typical of the kind of work which might have inspired Chardin. Chardin clearly intended his male and female subjects to balance and complement each other. *The Embroiderer* (Plate 19) is painted so she faces the viewer, whereas the student is seen from the back. She is absorbed in a reverie; he is hunched over his work in an attitude of deep concentration. The whites of the embroiderer's cap and apron, punctuated by the blue and red of the wools, tablecloth and pincushion, contrast with the almost monochromatic tones of the young student, broken up only by the red lining of his suit and the red of the sanguine drawing on the wall. There are possibly elements of a self-portrait in this little painting. Chardin's words on the subject of learning to draw were recalled by Diderot in his Salon criticism of 1765:

Chardin seemed to doubt that there could be any education longer and more painful than that of a painter, not even that of a doctor, a lawyer, or Sorbonne professor. 'At the age of seven or eight,' he said, 'they put a chalk-holder in our hand. We begin to draw, after engravings, eyes, mouths, noses, and ears, then feet, hands. Our back has been bent over the sketchbook for a long time when we finally come face to face with a statue of the *Hercules* or with the *Torso* [Belvedere], and little do you know of the tears shed on account of some satyr or gladiator … After spending days without end and lamplit nights before immobile and inanimate nature, we are presented with the living reality, and suddenly the work of all the preceding years seems to come to nothing; we were no more at a loss the first time we took up our pencil. One has to teach the eye to look at nature; and how many there are who have never seen it nor ever will! That is the agony of our life. They keep us five or six years in front of a model, then release us to our creative ability, if we have any. Whether or not one has talent is not decided in an instant.'

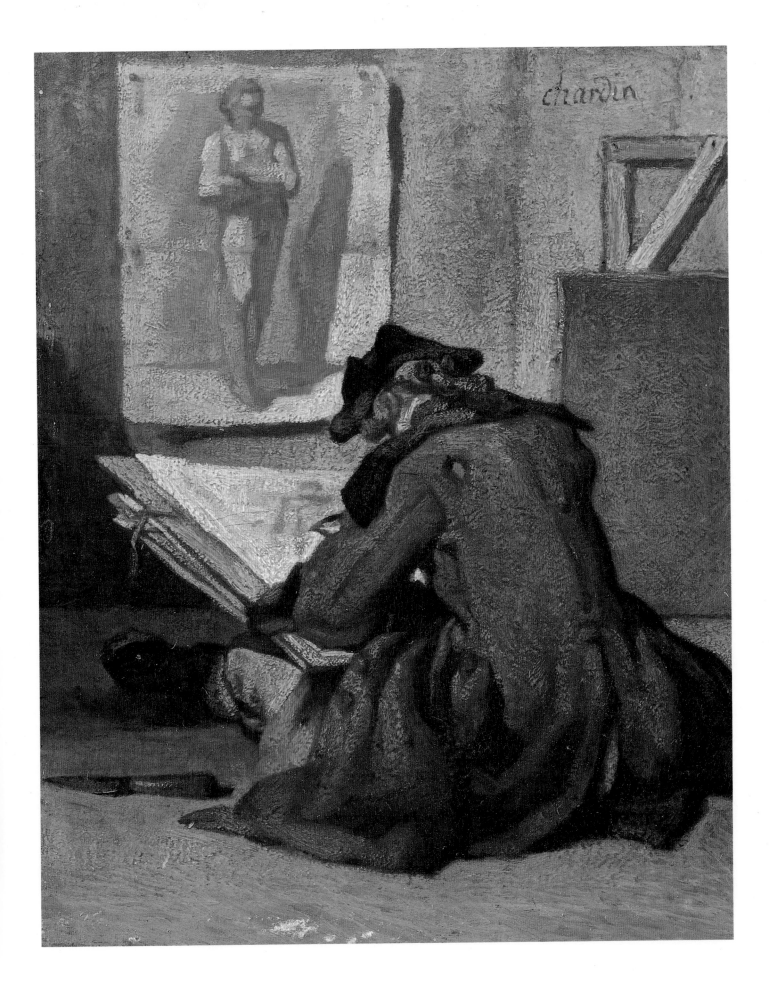

The Schoolmistress

1735–6. Oil on canvas, 61.5 x 66.5 cm. National Gallery, London

72

Critics have been tempted to see in this painting a portrait of the artist's own children or members of the Le Noir family, close friends of Chardin, but neither hypothesis can be taken seriously. This work is the artist's first important two-figure subject after the *Lady Sealing a Letter* (Plate 12) and *Soap Bubbles* (Plate 15), both painted in the early 1730s. In this painting, however, Chardin has dispensed with the rich background and the framing device of the window and focuses entirely on the figures. The younger child in this work resembles the companion of the boy blowing bubbles and has the same unformed features. His round, serious face contrasts with the indulgent yet maternal glance of his elder sister who points to the letters of the alphabet with her large knitting needle. Although they are not looking at each other, Chardin establishes a silent dialogue between them. It is his depiction of the emotional bond and the closeness of their relationship that makes this painting a unique family portrait and an endearing image of childhood.

Exhibited at the Salon of 1740 this work was engraved by François-Bernard Lépicié (1698–1755) the same year with the following verse:

If this charming child takes on so well
The serious air and imposing manner of a schoolmistress,
May one not think that dissimulation and ruse,
At the latest come to the Fair Sex at birth.

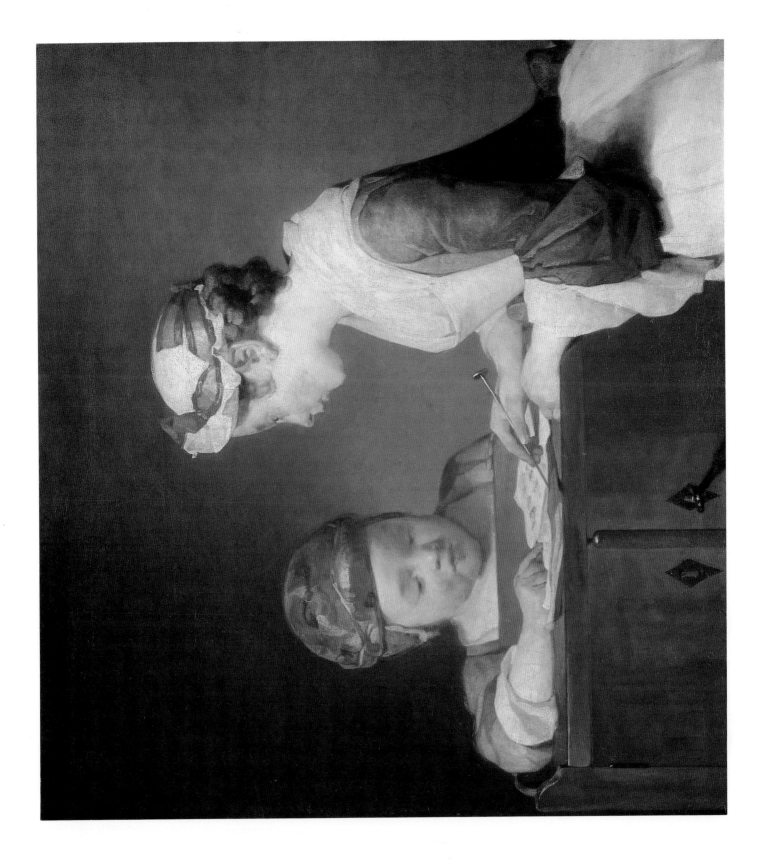

The House of Cards

1736–7. Oil on canvas, 60 x 72 cm. National Gallery, London

The alternative title of this painting is, 'The Son of Monsieur le Noir Amusing himself by Making a House of Cards'. Jean-Jacques le Noir was a cabinet-maker with a furniture shop of his own. He was a close friend of Chardin and, like the painter Aved, was a witness at Chardin's second marriage. At the Salon of 1743 Chardin exhibited a *Portrait of Jean-Jacques le Noir* which is now lost.

Chardin painted four different versions of this subject, the other three are in the Louvre, the National Gallery of Art in Washington (Fig. 28) and an English private collection, the latter painted as a companion piece to the *Lady Taking Tea* (Plate 18). The sitter in this painting is the most elegant of the three. He is portrayed wearing a tricorn hat and a ribbon in his hair and a fashionable coat of the period with octagonal buttons. Exhibited at the Salon of 1741, this work was engraved by Lépicié in 1743 with the verse:

Charming child, pursuing your pleasure,
We smile at your fragile endeavours:
But confidentially, which is more solid –
Our projects or your house?

Lépicié's verse alludes to the notion of mortality in the picture and to the futility of human endeavour and plans. In the Washington version, the Queen of Hearts projects from the open drawer suggesting an alternative interpretation – that love affairs are as fragile as houses of cards. More important, however, is Chardin's brilliant depiction of the world of childhood. His painting of the boy's impassive features, his concentration and air of self-sufficiency take the spectator back into a world of lost innocence.

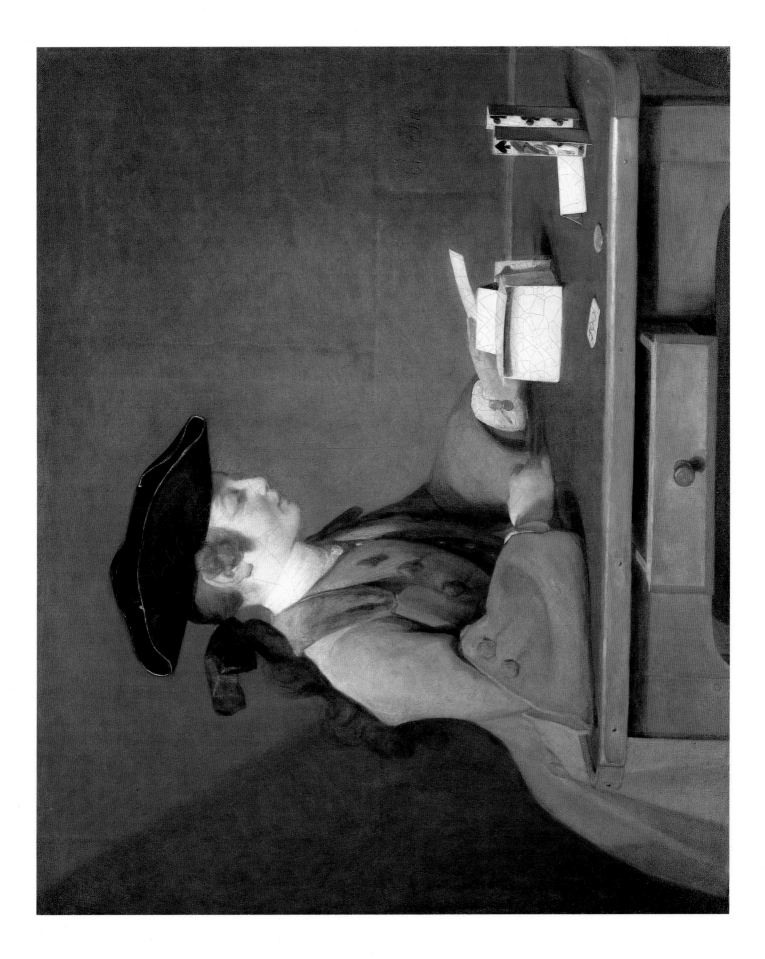

Girl with Shuttlecock

1737. Oil on canvas, 81 x 65 cm. Private collection

Fig. 28
The House of Cards
1737. Oil on canvas,
82 x 66 cm.
National Gallery of Art,
Washington, DC

The identity of the delightful little girl in this painting is unknown. It was painted to hang with the upright version of *The House of Cards* (Fig. 28). By 1774 both paintings were recorded in the collection of Catherine the Great. It was sold by Tsar Nicholas I and by the end of the nineteenth century had reappeared in a French private collection.

The charm and mystery of this painting lie in the artist's ability to capture the innocence of childhood. The little girl's face is soft and round, her features still unformed. She gazes obliquely out of the canvas, holding on to the top of the chair, perhaps because she is nervous or shy. The white of her billowing skirt and apron is echoed in the white feathers of the shuttlecock, the white on the handle of the racquet and the white background of her flowered bonnet. Some critics have interpreted this work as an allegorical portrait, the racquet and shuttlecock symbolizing the ephemeral nature of pleasure and amusement in contrast to the scissors and pincushion hanging from her waist which symbolize work or duty. Without doubt this work is one of Chardin's most beautiful creations and one of his most enchanting images of childhood, a genre at which he excelled and which he made his own.

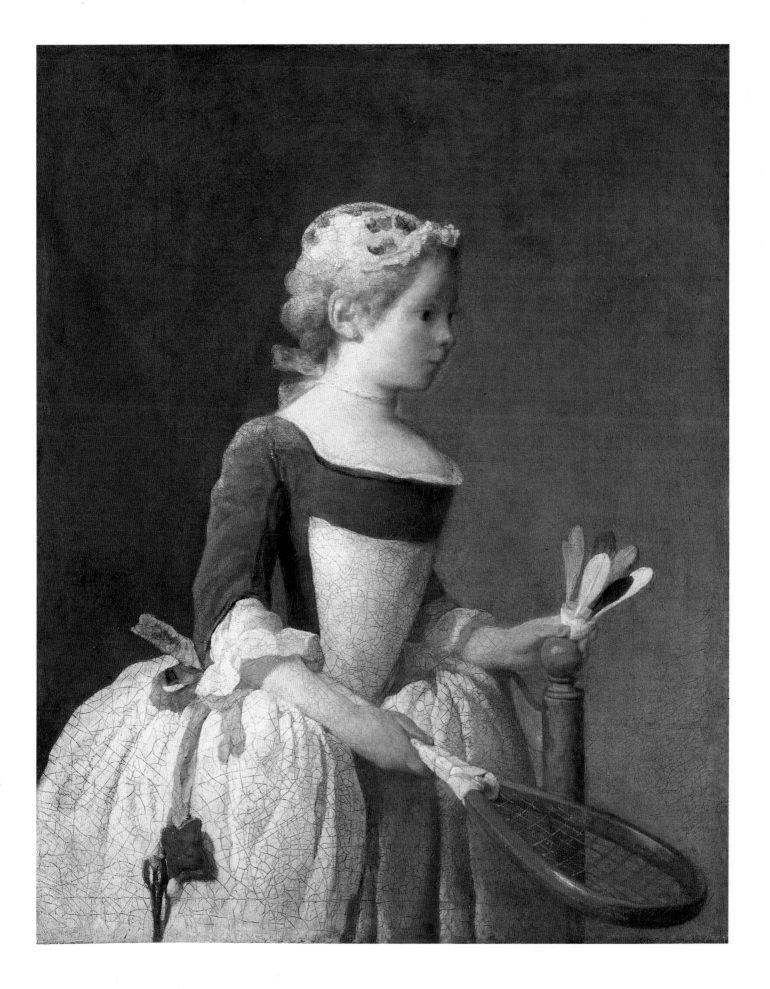

The Smoker's Case

*c*1737. Oil on canvas, 32.5 x 40 cm. Musée du Louvre, Paris

The subject matter of this painting is unusual and unique among Chardin's still lifes. The smoker's case was probably a highly valued object in the Chardin household since it is described in great detail in the 1737 posthumous inventory of Marguerite Saintard, Chardin's first wife:

> A smoker's case of rosewood, with key lock and metal handle, lined in fine satin, containing a silver set of two small goblets, small funnel, small candle-holder with extinguisher, four small pipe-stems and two small palettes, two crystal flasks with silver cap and chain, and two coloured porcelain pots – the entire case valued at twenty-five livres.

The open case is given pride of place in the composition and the artist surrounds it with objects of similar refinement – a blue and white faïence jug, a small figured porcelain bowl with silver-mounted lid and a silver-footed goblet and flask. Perhaps the artist's intention was that the painting should represent the vanity of worldly possessions. Smoke rising from the well-worn pipe may symbolize the passing of time and the temporality of worldly riches. Alternatively, if the work was painted in the year of Madame Chardin's death, it may have been done in her memory, the objects represented being things she dearly loved.

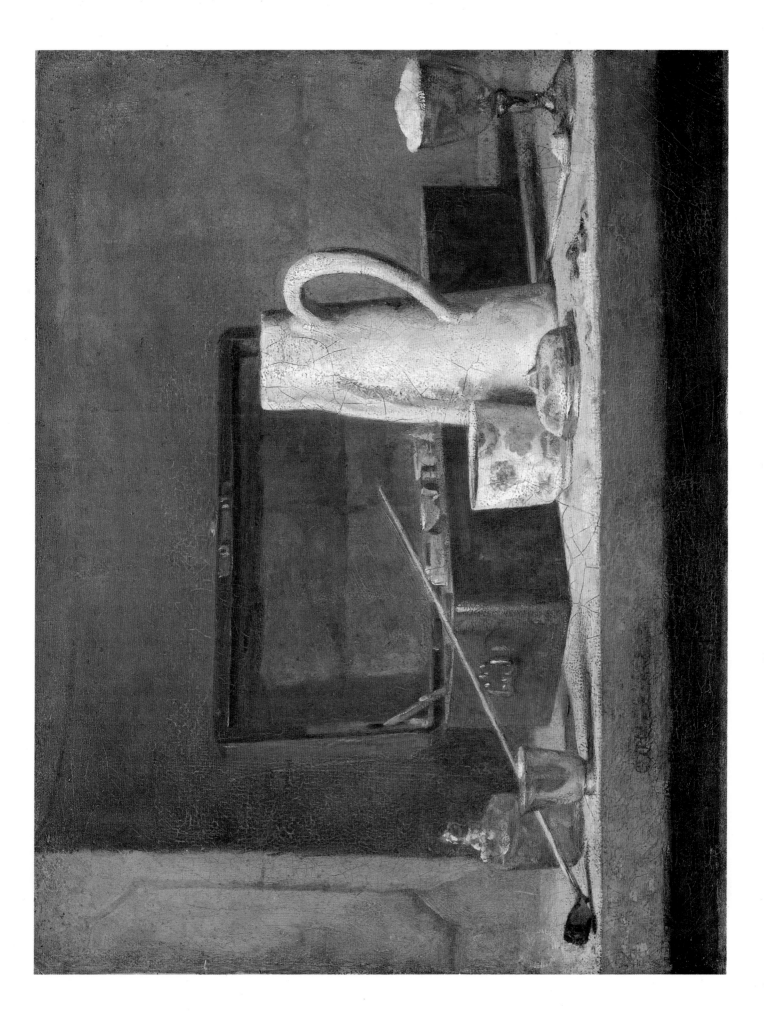

1738. Oil on canvas, 67 x 76 cm. Musée du Louvre, Paris

This beautiful painting, one of the most famous images in Chardin's *œuvre*, is a portrait of Auguste Gabriel, the younger brother of Charles Godefroy (Plate 17), at the age of ten. Born in 1728, he became an equerry and Controller-general of the Navy. He was also an important art collector and in 1782 at the sale of the Marquis de Ménars, formerly the Marquis de Marigny, he bought two of Watteau's most famous paintings, *Finette* and *L'Indifférent*, both now in the Louvre. In 1785, before setting out on a five-year trip to Italy, he sold his entire collection. After his death in 1813 a second sale was held revealing the evolution of his taste towards Neo-classicism.

The symbolism of this painting is clear. The child has abandoned his studies and has laid aside his books, paper and chalk, just visible in the open drawer, in order to play with his top. Childhood games are contrasted with the seriousness of adult life ahead. In this tender portrait Chardin captures perfectly an image of childhood innocence, a world of games from which adults are excluded but for which they still retain a feeling of nostalgia.

After its exhibition at the Salon in 1738, this painting was engraved by Lépicié in 1742 with the title 'The Spinning Top' accompanied by the following verse:

In the hands of caprice to which he abandons himself,
Man is only a top endlessly spinning;
His fate often depends on the movement,
Which fortune gives to his turning.

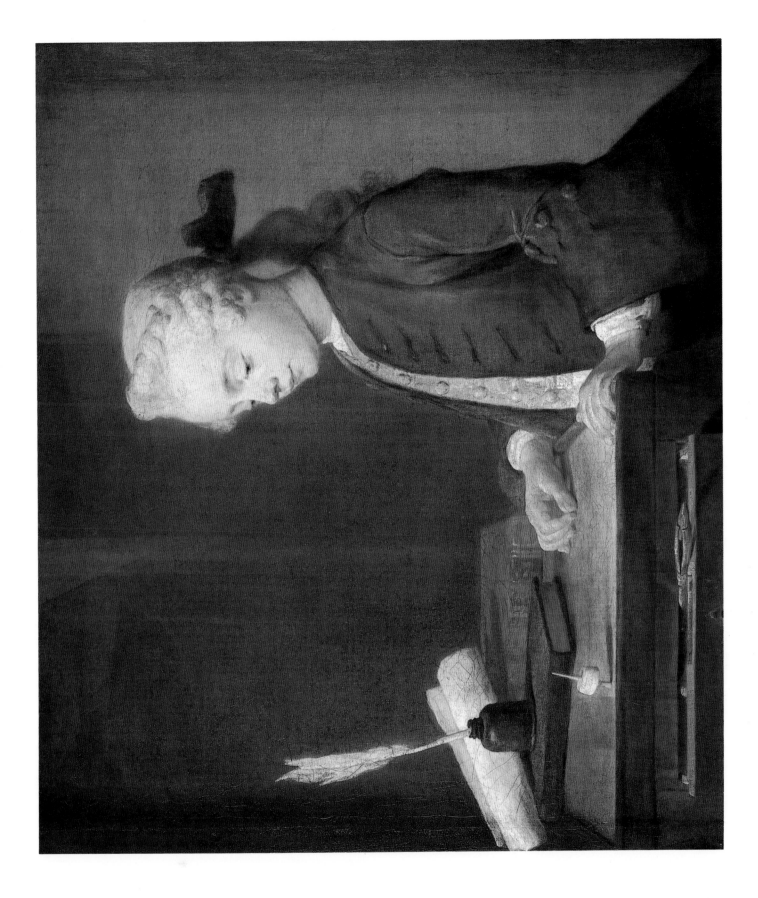

The Young Draughtsman

1737. Oil on canvas, 80 x 65 cm. Musée du Louvre, Paris

Chardin did two versions of this painting, both of which are dated 1737; the other is in Berlin. Exhibited at the Salon of 1738, the Louvre painting was in England by 1740 when it belonged to the musician, Francesco Geminiani (c1680–1762). At that time it was engraved in mezzotint by the famous English engraver John Faber (1684–1756).

Unlike his earlier treatment of the subject (Plate 20), which is Dutch in inspiration, this painting is closer in style and composition to *The House of Cards* (Plate 22) and the *Portrait of Auguste Gabriel Godefroy* (Plate 25). It is without doubt one of Chardin's most graceful portraits. The draughtsman, described by the Goncourt brothers in 1863 as 'tall and slender, elegant with his three-cornered hat firmly planted on his head, the flow of a large wig rippling down his back, indolently sharpening his pencil', is portrayed against a neutral background which throws him into sharp relief. The warm harmony of colour is punctuated only by the red ribbon of the portfolio and the blue of the apron. However, this painting is much more than an elegant, perfectly composed portrait. It is a study of the dreams and aspirations of youth.

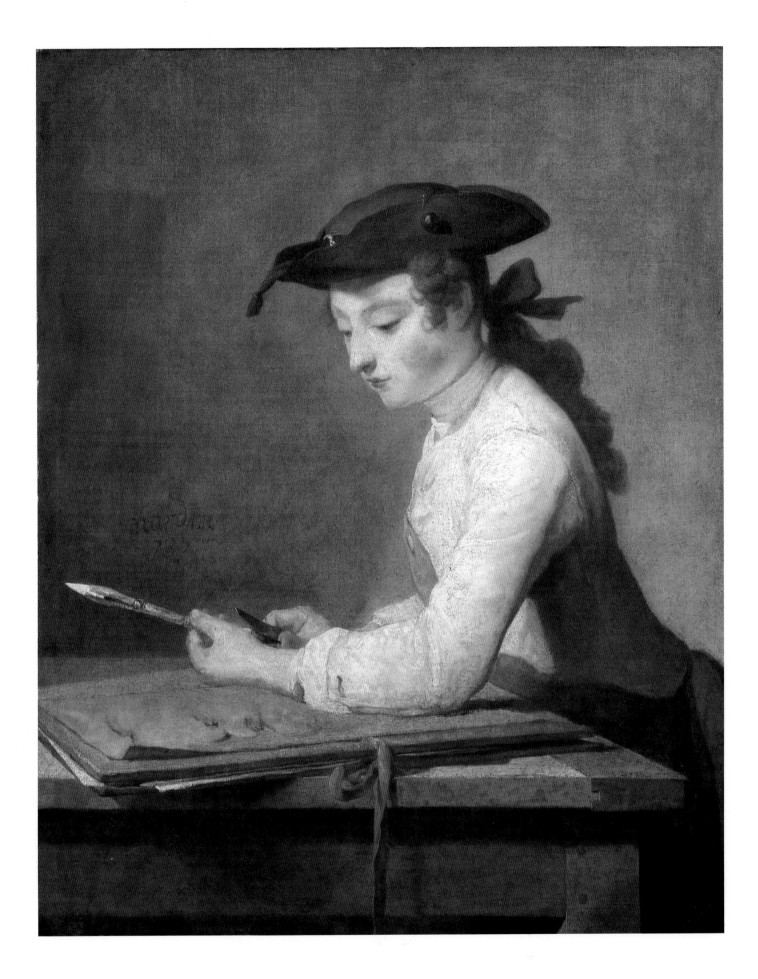

Rabbit with Copper Cauldron and Quince

*c*1735. Oil on canvas, 69 x 56 cm. Nationalmuseum, Stockholm

This painting has been described as one of Chardin's most beautiful still lifes. It was acquired in Paris by Count Tessin, who was Swedish Ambassador to the French Court between 1739 and 1742. In August 1741 Tessin sent the painting to Sweden and in 1749 it was acquired from him by the Swedish royal family.

The copper cauldron, a feature of the artist's kitchen still lifes of the early 1730s, seems disproportionate and fills almost half the canvas. Its sturdy volume makes the rabbit's inanimate body look limp and pathetic. The rabbit is painted life size and looks freshly slaughtered; drops of bright blood colour the ground which is brushed by its ears and whiskers. Its white tail and grey fur look soft to the touch next to the hard copper of the cauldron. Chardin was praised in his own day for his truth and accurate observation and it is this realism which makes him unique among French eighteenth-century painters.

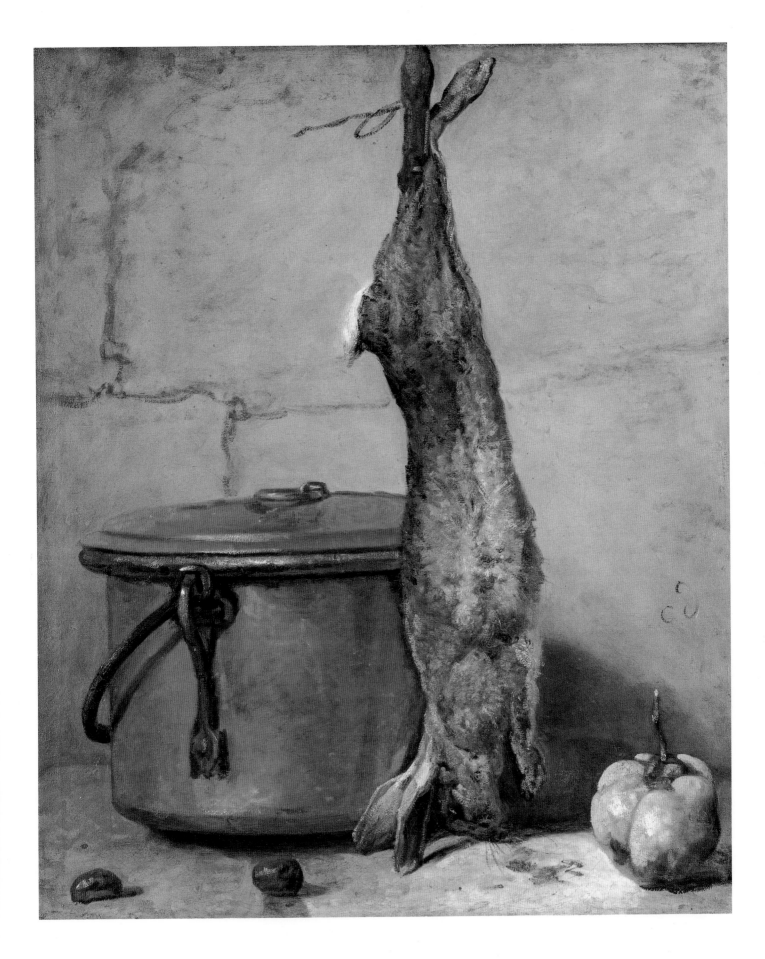

1738. Oil on canvas, 45.5 x 37 cm. Hunterian Art Gallery, University of Glasgow

Fig. 29
The Cellar Boy
1738. Oil on canvas,
46 x 37.2 cm.
Hunterian Art Gallery,
University of Glasgow

Fig. 30
JEAN-BAPTISTE
GREUZE
The Lazy Italian Girl
1757. Oil on canvas,
64.8 x 48.9 cm.
Wadsworth Atheneum,
Hartford, CT

Together with its companion piece, *The Cellar Boy* (Fig. 29), this painting was purchased by the Scottish physician, Dr William Hunter, possibly when he was in Paris in 1748. A version of *The Scullery Maid* was shown at the Salon of 1738 but that work was destroyed in the Second World War.

Both the scullery maid and the cellar boy appear to look out of their canvases at one another. Details in the two works also echo each other. The wooden vats, central to both compositions, are almost identical and the kitchen pans, jugs and bottles are recognizable from the artist's earlier kitchen still lifes. The ribbon and medallion around the maid's neck is echoed by the ribbon and key round the boy's waist. Both are engaged in mundane tasks, yet both are removed from their actions, motionless for a moment, expressionless and silent. Chardin exhibited the Salon version of *The Scullery Maid* for a second time in 1757 when the paintings of the young artist, Greuze, then only 27, were receiving critical acclaim. Naturally writers compared the two artists and although Greuze was praised for his expression and his draughtsmanship, Chardin was still considered to be the master in colour and originality. A comparison between Chardin's *The Scullery Maid* and Greuze's *The Lazy Italian Girl* (Fig. 30) exhibited at the same Salon perfectly illustrates the point.

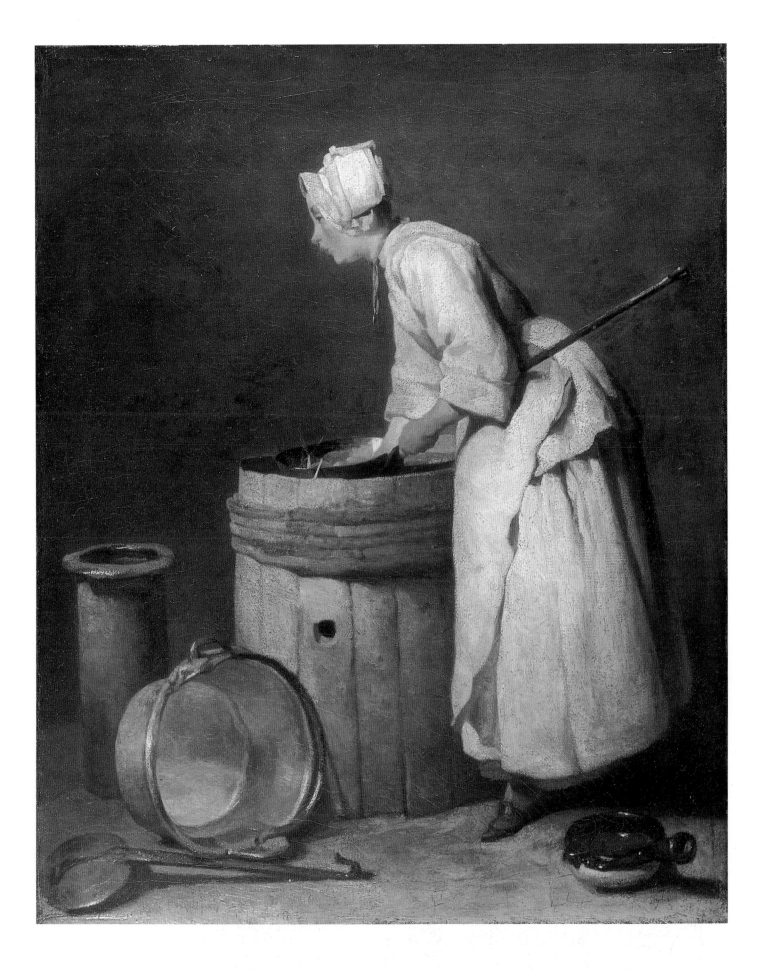

29 The Return from Market

1739. Oil on canvas, 47 x 38 cm. Musée du Louvre, Paris

Chardin painted three versions of this work, the other two are in the Charlottenburg Palace, Berlin and in the National Gallery of Canada in Ottawa. The Ottawa painting is probably the one exhibited at the Salon of 1738. *The Return from Market* is today one of Chardin's most famous paintings. After it was acquired by the Louvre in 1867 it had a major influence on French nineteenth-century painters. Henri Fantin-Latour (1836–1904) copied it and the French sculptor Raoul Larche (1860–1912) was inspired by it when he executed his *Monument to Chardin* in 1911 (present location unknown).

As in *The Scullery Maid* (Plate 28), Chardin makes his large female figure dominate the composition. The background, too, is skilfully composed and contains still-life elements from other paintings. Through the doorway we see the copper urn which he made the subject of an earlier picture (Plate 11) and which had played an important role in the *Woman at the Urn* (Plate 13). Chardin uses a device frequently found in Dutch seventeenth-century paintings of constructing his composition so that our eye moves from dark to light through a series of open doorways. The child who stands at the open doorway is reminiscent of the *Girl with Shuttlecock* (Plate 23) as she stands immobile in front of the shadowy male figure. Attention, however, is focused on the weary servant girl who leans heavily against the sideboard, one arm around the freshly purchased loaves which still look warm. All our sympathy is for her as she gazes softly out of the canvas, her thoughts and dreams removing her from the banality of everyday life. The French critic André Malraux gave one of the best assessments of this picture in 1951 when he described the artist thus:

Chardin is not simply a little master of the eighteenth century who is more refined than his rivals; he is, like Corot, a gentle imperious simplifier. His quiet mastery overthrew the baroque still life of Holland and made mere decorators of his contemporaries; in France nothing was able to compete with him from the death of Watteau to the Revolution.

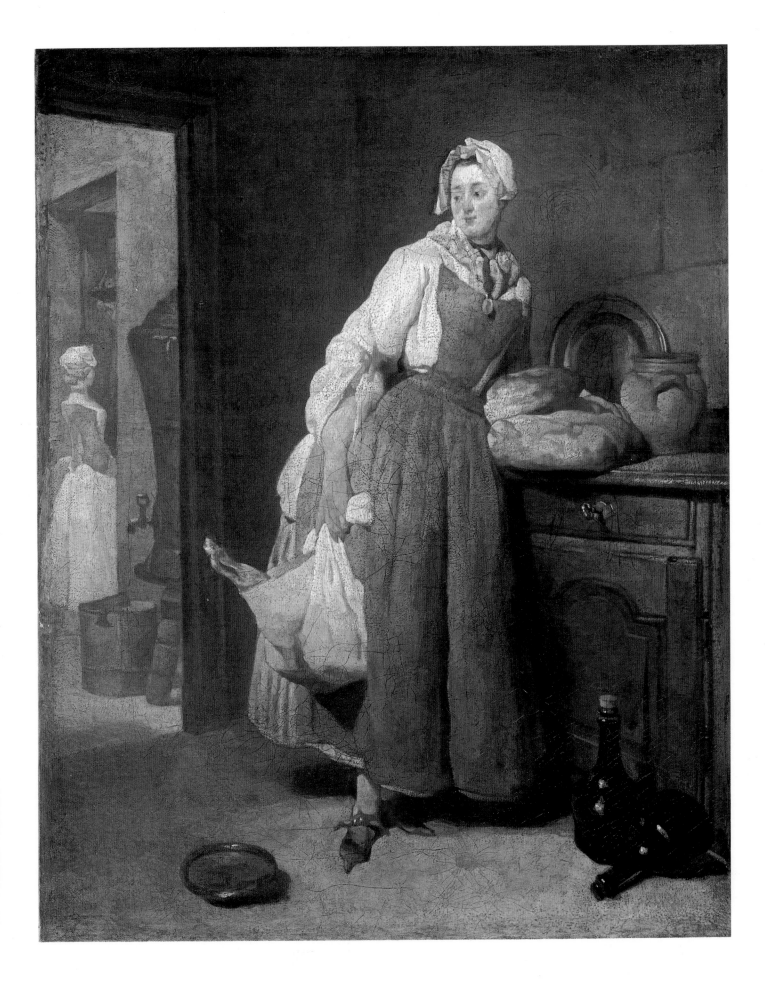

The Governess

1738. Oil on canvas, 46.5 x 37.5 cm. National Gallery of Canada, Ottawa

Exhibited at the Salon of 1739, this work was singled out for praise by the Abbé Desfontaines (1685–1745):

> The inimitable Chardin always makes us admire the simple and true which rule his works and which attracts everyone because his perfect imitation of nature strikes every eye … his reputation increases every day and everything he does deserves more and more public regard.

According to the connoisseur and critic Mariette, this was the painting which made Chardin's reputation. Certainly it is his most sophisticated composition to date because in it he combines elegant figures and beautiful still-life detail. The child resembles all the other children he had painted previously and his playthings – cards, racquet and shuttlecock – all reappear here on the elegant parquet floor. The governess, too, resembles Chardin's other female models both in dress and expression and her work basket is recognizable from *The Embroiderer* (Plate 19). The work resembles a scene from a play and could be interpreted as a development of *The Schoolmistress* (Plate 21). The child has grown up but has the same downcast expression and the governess, although seeming to scold, looks tenderly at her protégé. A similar silent dialogue is taking place between them.

After its exhibition at the Salon, this painting was sold to Prince Joseph Wenzel of Liechtenstein, Austrian Ambassador to the French Court between 1737 and 1741. When the Liechtenstein collection was dispersed in the 1950s, this painting was acquired by the National Gallery of Canada.

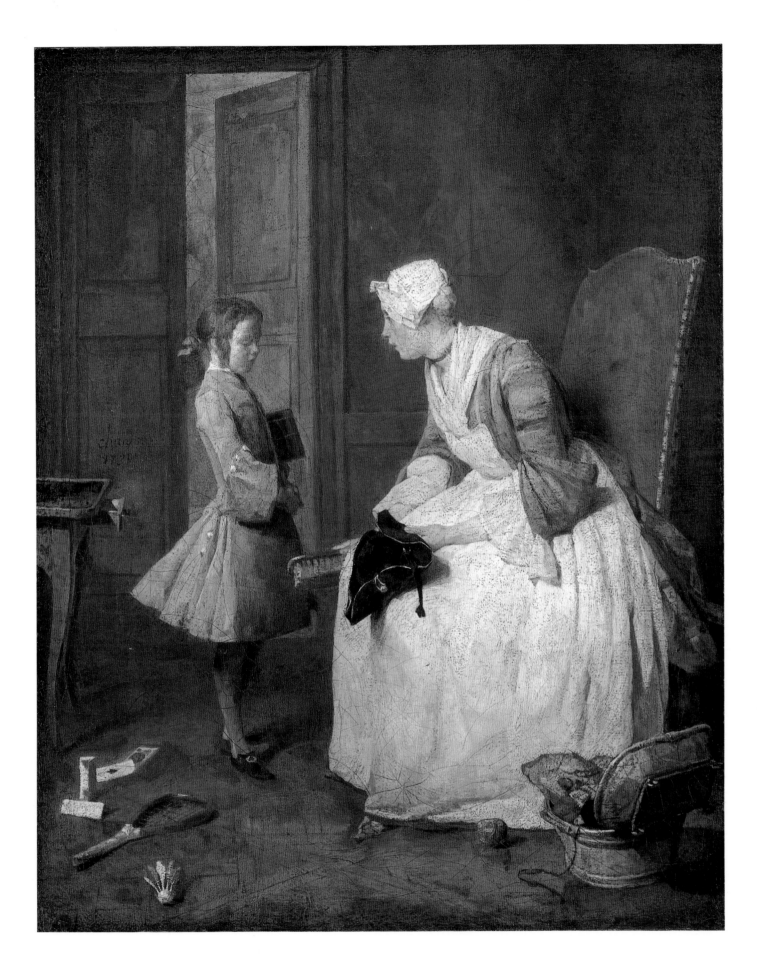

The Diligent Mother

1740. Oil on canvas, 49 x 39 cm. Musée du Louvre, Paris

On 27 November 1740 Philibert Orry (1689–1747), Minister for Culture, presented Chardin to Louis XV at Versailles. This was the only official meeting between King and painter. Chardin offered the King *The Diligent Mother* and its companion piece *Saying Grace* (Plate 32). By 1784 the paintings had been moved to the Louvre and in 1845, when new rooms dedicated to French eighteenth-century painting were opened, they were again put on show to the public. From that moment until the outbreak of war in 1914, these two paintings were among the most popular works in the Louvre.

As in *The Governess* (Plate 30) Chardin portrays his figures in a typically bourgeois interior, restrained in its elegance rather than sumptuously decorated. This is clearly a workroom, the floor is tiled, a teapot, cup and saucer stand on the mantelpiece, a yarn-winder and work-box are the only visible furnishings. The piece of embroidery that extends between mother and daughter symbolizes the emotional bond and the silent dialogue taking place between them. The obedient, downcast expression of the child contrasts with the knowing, expressive face of the mother.

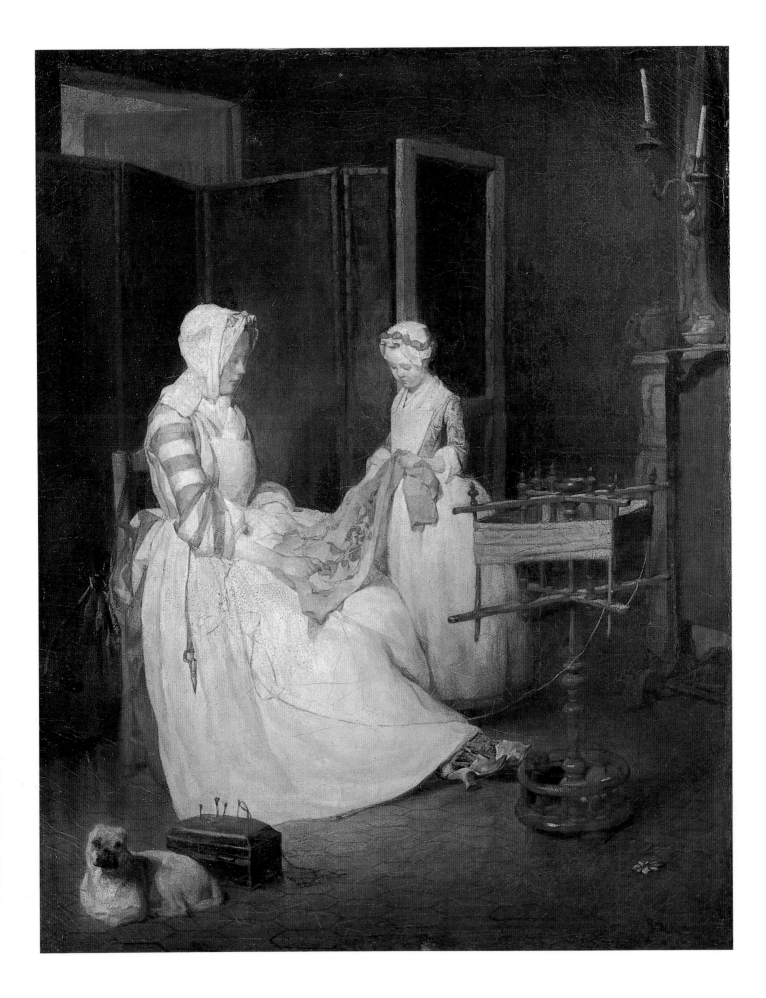

1740. Oil on canvas, 49.5 x 38.5 cm. Musée du Louvre, Paris

Fig. 31
Sketch for Saying
Grace
1740. Oil on canvas,
46.5 x 38 cm.
Private collection

This work is the companion piece to *The Diligent Mother* (Plate 31). Both paintings were exhibited at the Salon of 1740 and offered to Louis XV the same year when the artist was presented to the King. A sketch for the painting (Fig. 31) shows how Chardin altered the composition in the final painting. In the sketch the elder child is standing while the mother is seated. The pose of the mother and younger child is closer to that of the two figures in *The Diligent Mother* although there the poses have been reversed. The motif of the cloth which holds them together is already evident in the sketch, and the stance of the elder child resembles that of the little girl in *The Diligent Mother*. It was perhaps in the construction of the sketch that Chardin found the idea for the two finished compositions which balance each other perfectly. The darkness of the two interiors echo each other and the two main female figures wear contrasting dark and light dresses. The brazier in the right-hand corner of *Saying Grace* balances the pug and the work-box in *The Diligent Mother*. As is usual with Chardin, it is easy to find antecedents for this picture in Dutch seventeenth-century painting. *A Peasant Family at Mealtime* (Private collection) by Jan Steen (1625/6–79) is a typical example.

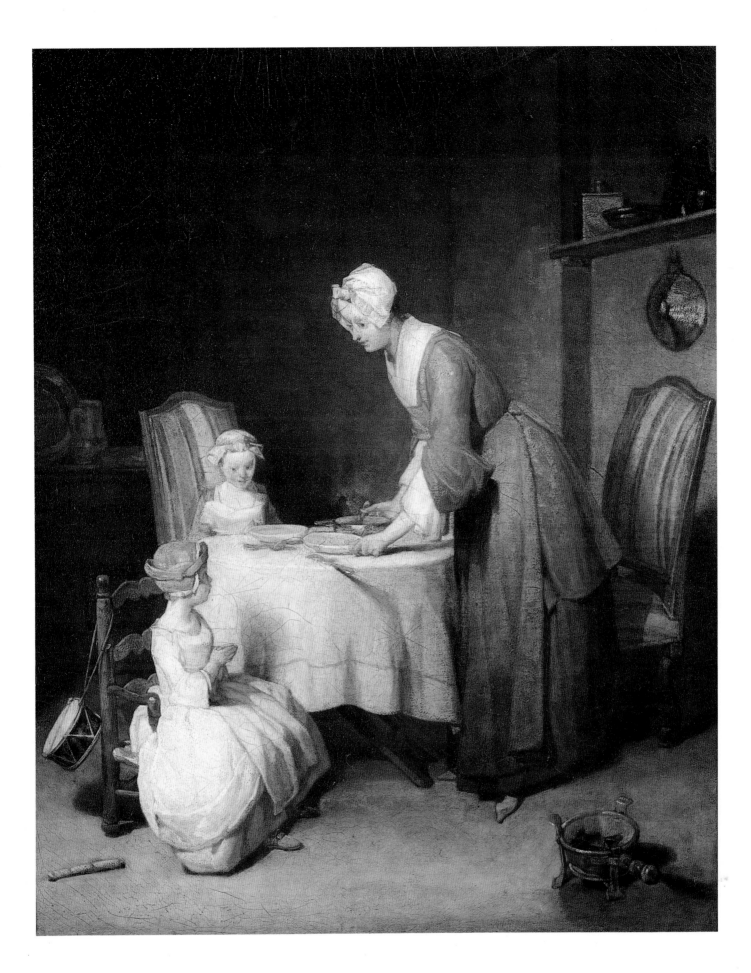

The Morning Toilet

1741. Oil on canvas, 49 x 39 cm. Nationalmuseum, Stockholm

This painting was commissioned from the artist by the Swedish Ambassador to the French Court, Count Tessin, who lent it to the Salon exhibition of 1741. It is the most refined of Chardin's genre subjects to date, both in style and composition. In a dressing room a mother adjusts her daughter's bonnet before they set off to church. Both are elegantly dressed for the occasion, the mother's muff and missal lie ready on the nearby stool. The marquetry clock says a few minutes to seven, the time of Mass. In this painting Chardin captures perfectly the loving care and attention the mother devotes to her daughter and the coquetry the child herself displays as she looks sideways at her reflection in the mirror. When engraved by Philippe le Bas (1707–83) the verse on the print reads:

Before reason enlightens her,
She takes from the mirror seductive advice
On desire and the art of pleasing;
Beautiful women, I see, are never children.

The vanity of the child, who looks admiringly at her elegant reflection, is itself symbolic. The theme of the vanity of worldly possessions and the transience of life is nearly always present in Chardin's works, however subtle. Thus the silver candlestick and smoke, the silver ornaments on the dressing table and the mirror itself all symbolize earthly riches which, like the child's youthful beauty, will one day fade. If this is the work's underlying theme, however, it is not its essence. Rather Chardin, as in all his genre subjects of this period, presents an eternal cameo of maternal love and affection.

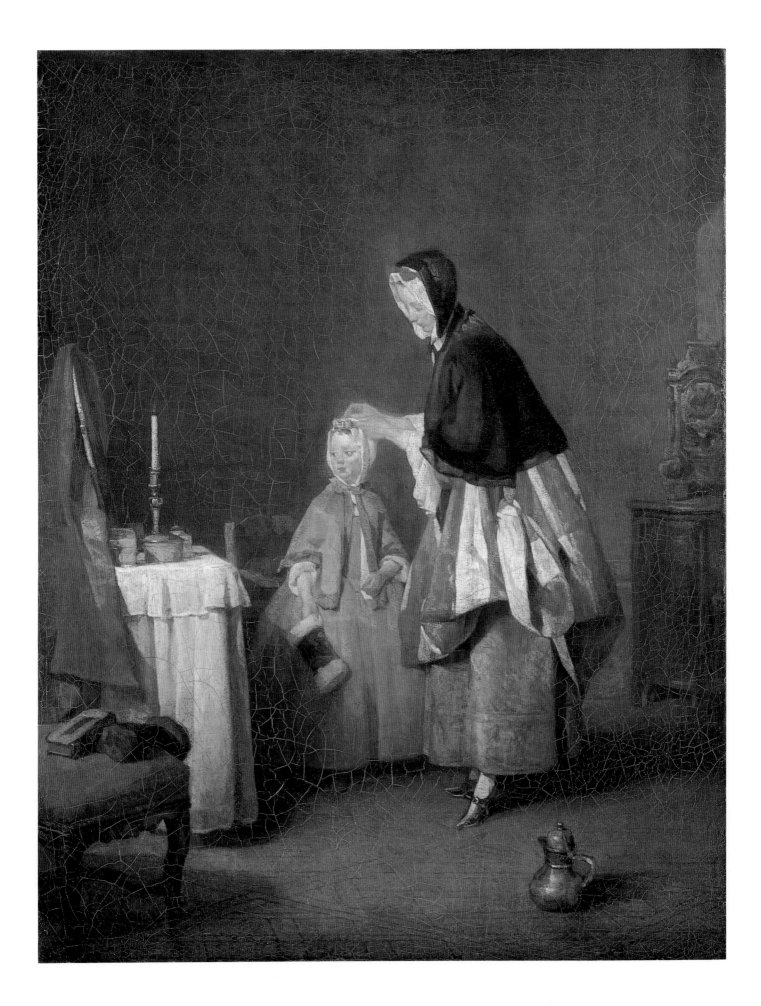

The Bird-Song Organ

1751. Oil on canvas, 50 x 43.5 cm. Musée du Louvre, Paris

This was Chardin's first royal commission. The request came in 1751 from the Surveyor General of the King's Buildings, Le Normant de Tournehem, through Charles-Antoine Coypel, Director of the Academy and First Painter to the King. Chardin was paid 1500 livres for it in 1752. He acknowledged his gratitude to Coypel by including in this work two engravings after Coypel's paintings, *Thalia Ejected by Painting* (Chrysler Museum of Art, Norfolk, VA) and *Children's Games* (Private collection), a fragment of which can be seen on the wall of the elegant drawing room. He also acknowledged his debt to Lépicié, the engraver of Coypel's paintings and of so many of Chardin's own works. Lépicié was not only a skilled engraver but he was also Secretary to the Academy and an influential figure in its hierarchy. In 1752, the year after Chardin received this royal commission, he was awarded the first of his royal pensions.

Shown at the Salon of 1751, this work was warmly praised for its refinement. Delicately and smoothly painted, it owes much to the polished genre paintings of Dutch seventeenth-century painters such as Ter Borch or Van Mieris, while also anticipating the works of early nineteenth-century French painters such as Louis-Leopold Boilly (1761–1845). The sitter may represent the artist's second wife, Françoise-Marguerite Pouget. She is portrayed in an elegant interior seated at her embroidery frame. With her right hand she turns the handle of a cylindrical organ, used to teach canaries to sing.

One of the artist's last genre paintings, this composition is elegant and refined and its sophisticated tone indicates that it was intended for a royal residence. In fact, the work never entered the royal collection, remaining in the possession of Le Normant de Tournehem until 1753 when it became the property of his successor as Surveyor General of the King's Buildings, the Marquis de Vandières, younger brother of Madame de Pompadour and later Marquis de Marigny.

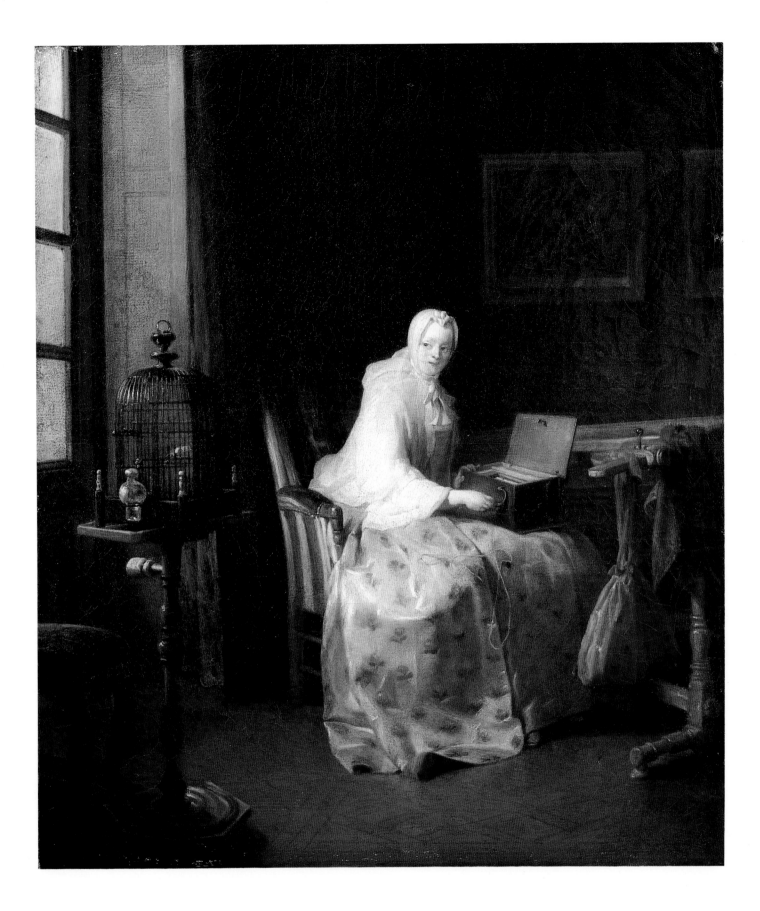

35 Flowerpiece: Carnations, Tuberoses and Sweet Peas

1760–3. Oil on canvas, 44 x 36 cm. National Gallery of Scotland, Edinburgh

In the 1750s and 1760s, Chardin almost abandoned genre painting completely. His exhibits at the Salon were either paintings from the 1730s and 1740s, or repetitions of earlier subjects. Now in his fifties the artist returned to still-life painting, but these late works are far more sophisticated productions and at the same time more freely painted.

Flower paintings are extremely rare in Chardin's *œuvre* and this beautiful example is the only one to have survived. While some are listed in the Salon catalogues of 1761 and 1763, others are mentioned in the artist's own posthumous inventory and in those of his fellow artists and patrons such as Thomas-Aignan Desfriches (1715–1800). Flowers appear in a painting formerly owned by Desfriches, the *Hare with a Pot of Gillyflowers and Onions* (Institute of Arts, Detroit, MI) datable to around 1760.

In a blue and white Delft or Chinese vase Chardin has painted a simple arrangement of white carnations, tuberoses and sweet peas. One red carnation and a few petals lie on the table. The composition is classical in its extreme simplicity, the blue and white flowers echoing the blue and white of the vase, the neutral background anticipating the flower paintings of the Impressionists, especially Fantin-Latour.

In his *Portrait of Monsieur David David-Weill* (Private collection), painted in 1928, Édouard Vuillard (1868–1940) portrayed the famous French collector David David-Weill with this flower painting and other Chardins he owned in the background.

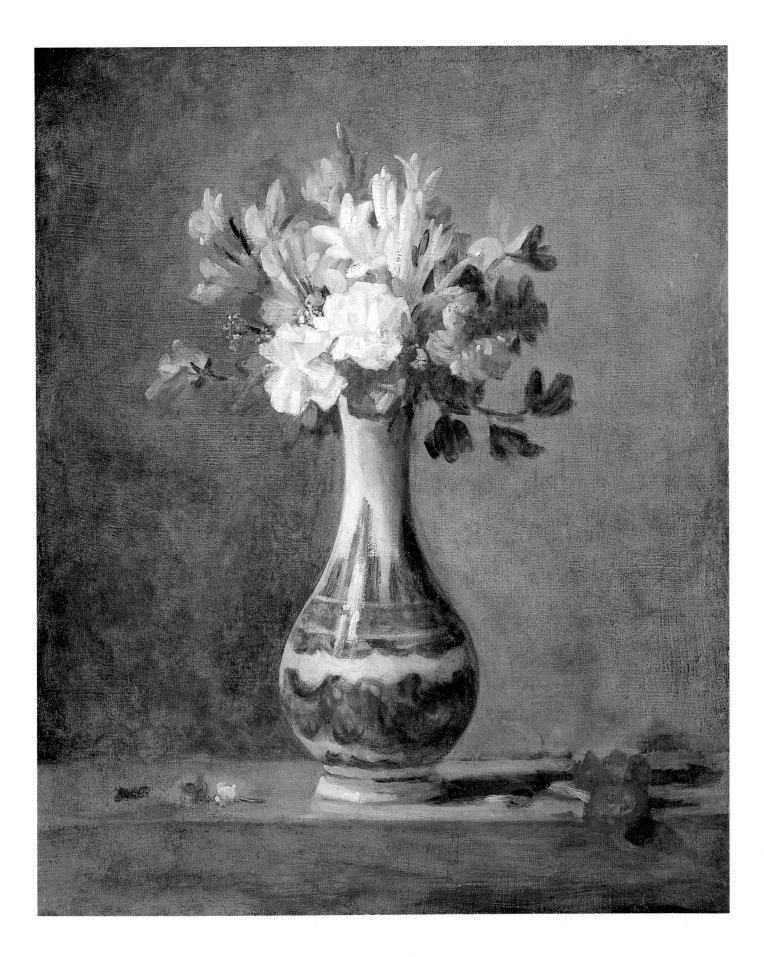

The Butler's Table

1756. Oil on canvas, 38 x 46 cm. Musée des Beaux-Arts, Carcassonne

In his late still lifes, Chardin frequently created far more complex arrangements than in his paintings of the late 1720s and 1730s. *The Butler's Table* was painted to hang with *The Kitchen Table* (Fig. 32) and both were exhibited at the Salon of 1757. At that time they belonged to the young collector, Ange-Laurent la Live de Jully (1725–79). He came from an extremely wealthy Parisian family and was one of the first to form an important collection of contemporary French paintings and sculpture in his house near the place Vendôme. He was himself a talented draughtsman and engraver. In 1756 he bought the appointment of Introducteur des Ambassades, whose role was to introduce new ambassadors at court and host dinners for diplomats each week at Versailles. He was a friend of Madame de Pompadour and these two canvases would have fitted in well with his elegant lifestyle. Although the objects in *The Kitchen Table* are familiar to us from Chardin's earlier kitchen still lifes, those in *The Butler's Table* are entirely new, although the red lacquer table is recognizable from the *Lady Taking Tea* (Plate 18). Particularly beautiful is the porcelain soup tureen and the silver-topped oil and vinegar bottles. All these objects testify to the artist's own more prosperous lifestyle since his second marriage in 1744 to the wealthy widow, Françoise-Marguerite Pouget, and his subsequent move to a grace and favour apartment in the Louvre.

Fig. 32
The Kitchen Table
1755. Oil on canvas,
39 x 47 cm.
Museum of Fine Arts,
Boston, MA

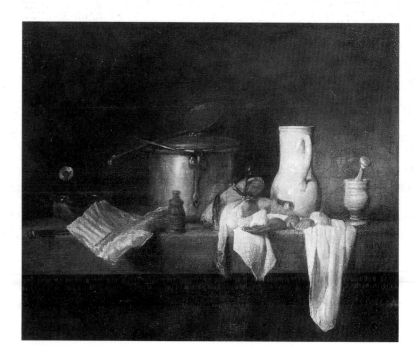

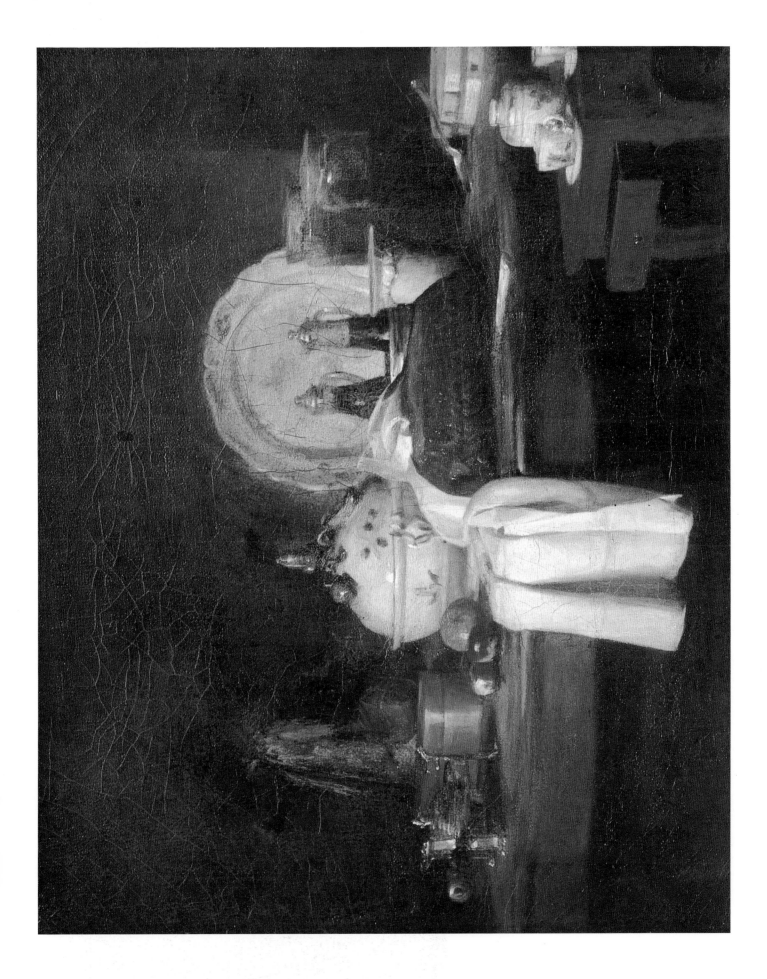

The Jar of Apricots

1758. Oil on canvas, 57 x 51 cm. Art Gallery of Ontario, Toronto

This painting and its companion piece, *The Sliced Melon* (Fig. 33), are among the most beautiful of Chardin's late still lifes. They belonged in the eighteenth century to the famous royal goldsmith, Jacques Roettiers (1707–84) and were in his collection when shown at the Salon of 1761.

Oval compositions are rare in Chardin's work although he did favour them later in his career. The objects in each work are perfectly balanced and arranged on their marble consoles which are curved to echo the oval of the compositions. In both paintings the eye is drawn to the details – to the delicate string around the jar in which the apricots are partially submerged, to the steam rising from the porcelain coffee cup, to the blue-wrapped sugar loaf and the two mysterious boxes hiding their contents. Chardin's genius as a still-life painter lies in the apparent natural grace with which objects such as the sliced melon and peaches have been arranged.

Fig. 33
The Sliced Melon
1758. Oil on canvas,
57 x 32 cm.
Private collection

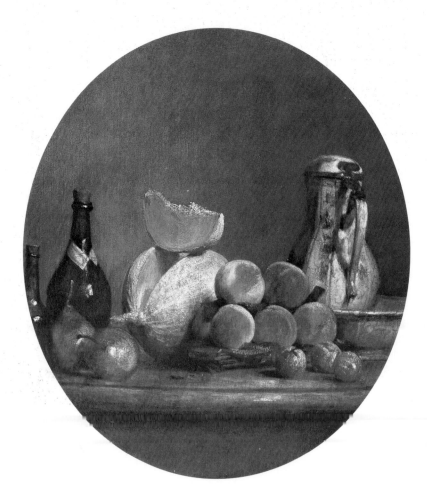

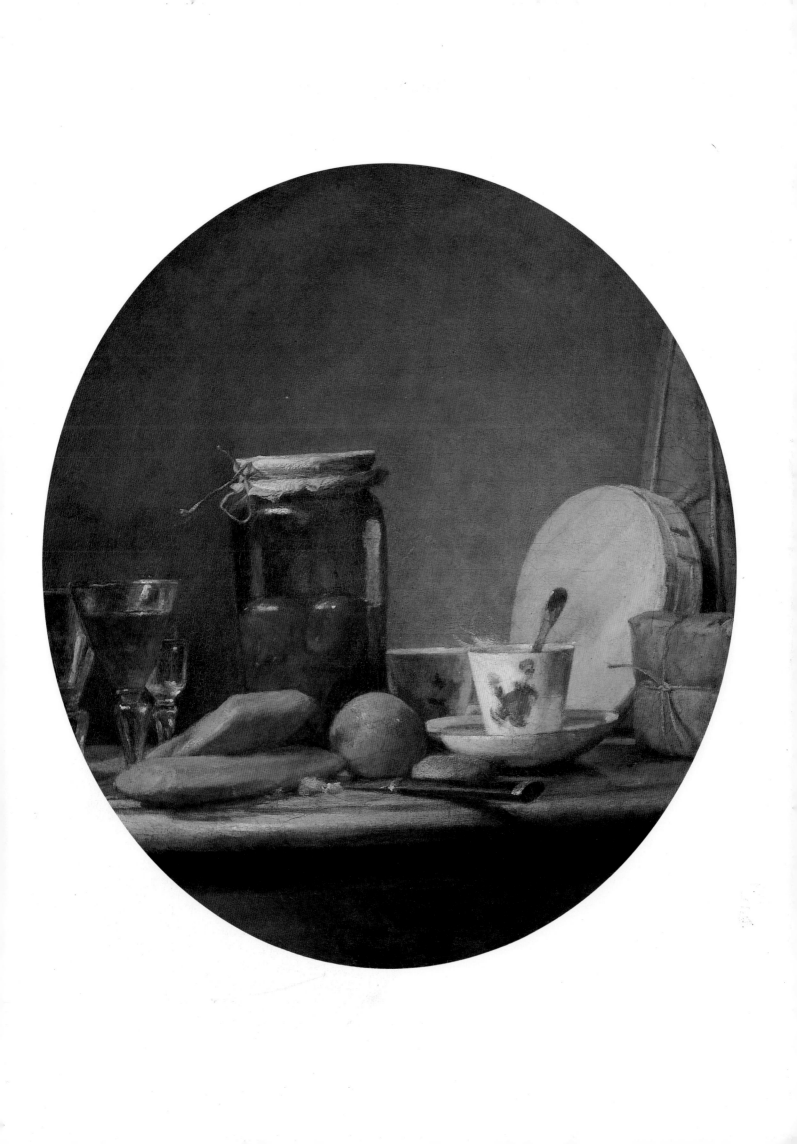

The Olive Jar

1760. Oil on canvas, 71 x 98 cm. Musée du Louvre, Paris

Of the six still lifes Chardin sent to the Salon of 1763, this painting received the greatest praise from Diderot. The objects are similar to those in *The Jar of Apricots* (Plate 37) although here the artist seems to be contrasting the sweet and the savoury, the refined with the unrefined. Thus the coarse pâté is balanced by the Meissen bowl, the salty olives with the sweet pears, the bitter Seville orange with the marzipan biscuits. Diderot's analysis of this work is perhaps the best ever written:

> To look at the paintings of others, it seems that I need different eyes; to look at those of Chardin, I need only to make good use of those nature has given me. If I were to destine my child for a career in painting, that is the painting I would buy. 'Copy that for me', I would tell him, 'copy that for me again'. But perhaps nature is no more difficult to copy. This porcelain vase is of porcelain; these olives are really separated from the eye by the water in which they float; all you have to do is take these biscuits and eat them, open this Seville orange and squeeze it, pick up the glass of wine and drink it, take these fruits and peel them, put your hand on this pâté and slice it. Here is one who understands the harmony of colours and reflected light. O Chardin! It's not white, red or black pigment that you crush on your palette: it's the very substance of the objects, it's air and light that you take up with the tip of your brush and fix onto the canvas … I have been told that Greuze, walking upstairs to the Salon and noticing the piece by Chardin which I have just described, looked at it and went on, heaving a deep sigh. That praise is briefer and better than mine.

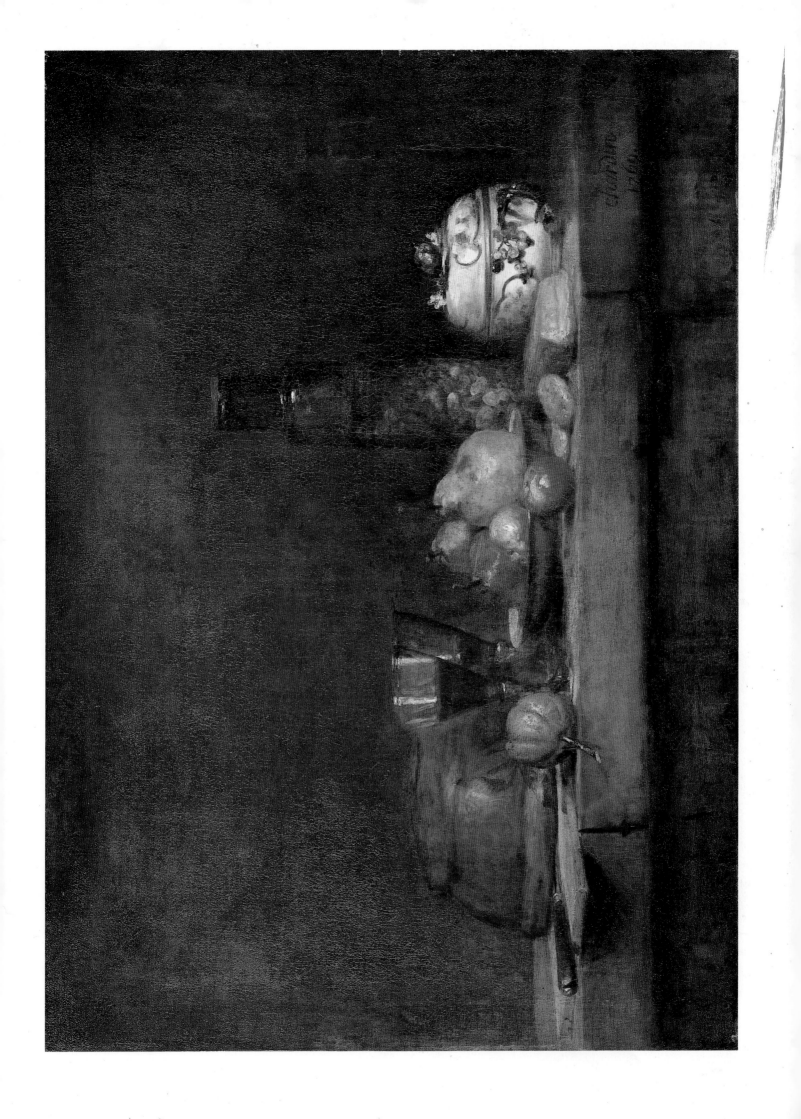

Basket of Wild Strawberries

1761. Oil on canvas, 38 x 46 cm. Private collection

In the 1760s Chardin executed some still lifes of extreme simplicity and refinement as well as his larger more complex works. Similar in date to his only surviving flower painting which it in some way resembles, this canvas produces the same effect of mystery and calm. Exhibited at the Salon of 1761, it was not mentioned by the critics but was eulogized in the second half of the nineteenth century by the Goncourt brothers:

> These two carnations: they are nothing but a fragmentation of blues and whites, a kind of mosaic of silvered enamellings in relief; step back a little, the flowers rise up from the canvas as you move away … such is the miracle of Chardin's art; modelled in the mass and the surroundings of their outlines, drawn with their own light, made so to speak of the essence of their colours, they seem to detach themselves from the canvas and come alive by means of a marvellous working of optics in the space between painting and spectator.

Minimalist in design and limited in its colour range of only red and white this painting is one of Chardin's most poetic late works.

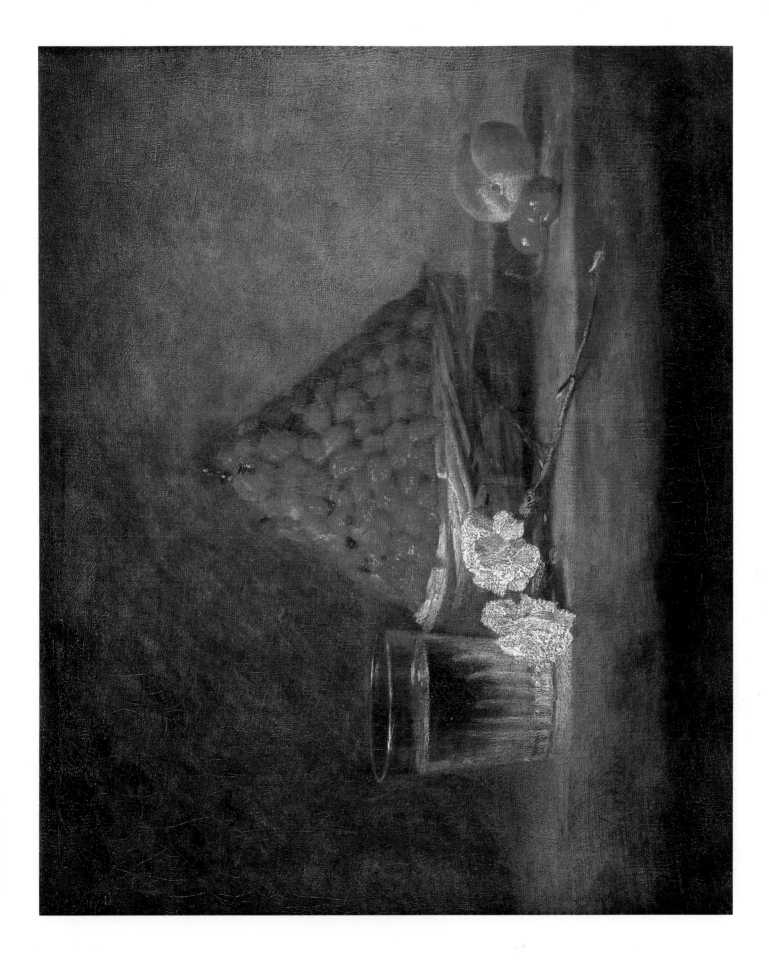

Glass of Water and a Coffee Pot

*c*1760. Oil on canvas, 32.5 x 41 cm. Carnegie Museum of Art, Pittsburgh, PA

This work is similar in composition to the *Basket of Wild Strawberries* (Plate 39) and probably dates from the same period, 1760–1. It is apparent from an infrared reflectogram of the painting (Fig. 34) that Chardin originally painted a basket of strawberries on the canvas but then modifed the composition. By substituting the coffee pot for the strawberries, however, he kept the same pyramid form of the composition. The two pictures are extremely close in design, the garlic bulbs, like the carnations, are reflected in the water while the garlic stems, like those of the flowers, break the hard edge of the table. Perhaps even more brilliant in its simplicity than the *Basket of Wild Strawberries* this painting had an enormous influence on the French Realist painters of the nineteenth century and is among the most magnificent of Chardin's late still lifes. The twentieth-century writer and poet Francis Ponge admired Chardin's simplicity and clarity of vision, saying: 'Endeavour to treat the most common subject in the most ordinary fashion, and your genius will come forth.'

Fig. 34
Infrared reflectogram
of *Glass of Water and a Coffee Pot*
Carnegie Museum of Art,
Pittsburgh, PA

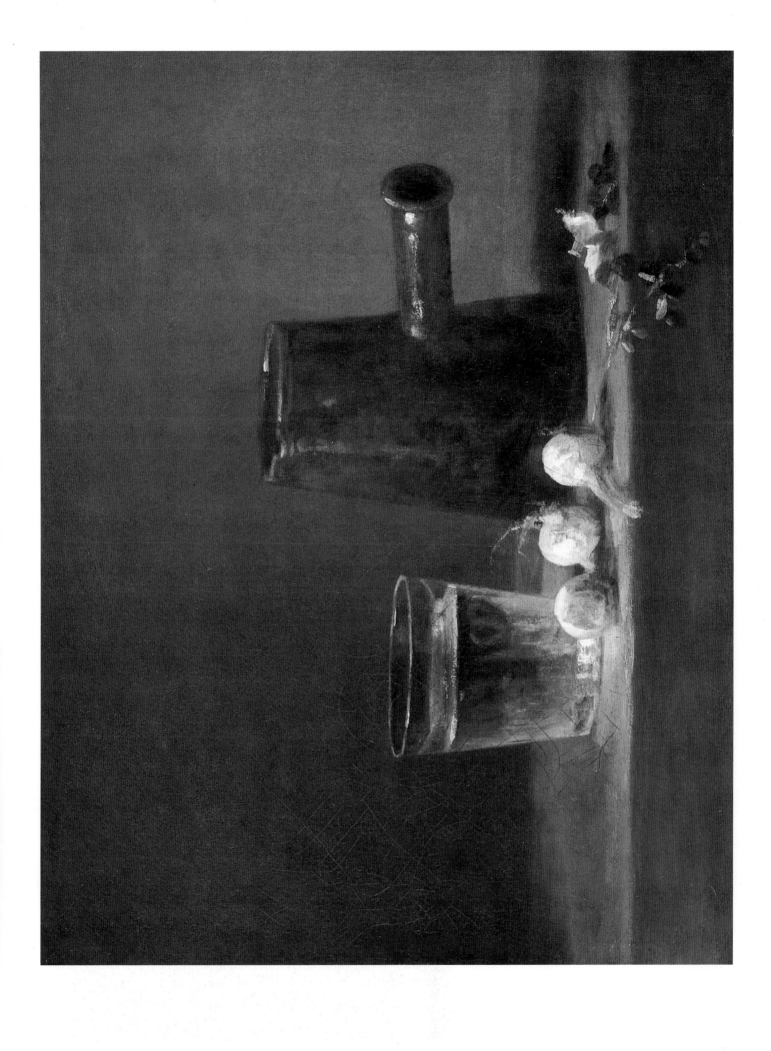

41 Grapes and Pomegranates

1763. Oil on canvas, 47 x 57 cm. Musée du Louvre, Paris

Chardin's two most elaborate still lifes of the early 1760s and which he probably exhibited at the Salon of 1763 are this painting and *The Brioche* (Plate 42). They may have belonged to the Count de Saint-Florentin (1705–77), who was one of Louis XV's most powerful ministers. They were described by a Salon critic as the most beautiful works he had ever painted because of his understanding of colour and the effects of direct and reflected light.

The composition, characterized by a sense of profusion, is dominated by the elegant Vincennes porcelain water jug which Chardin had used in *The Sliced Melon* (Fig. 33). Everything shines and glistens in the light, the bloom on the plump grapes which hang in bunches across the stone ledge, the succulent flesh of the opened pomegranates, the red wine shimmering in the glasses. Exotic and at the same time refined, this painting must rank as one of the artist's most seductive late works.

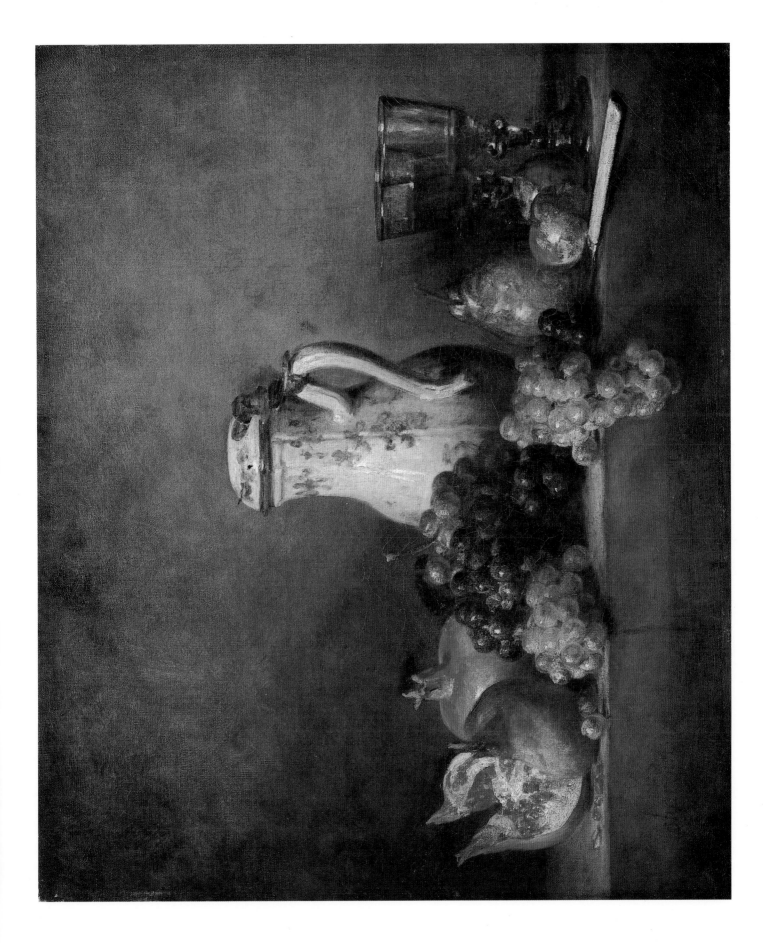

The Brioche

1763. Oil on canvas, 47 x 56 cm. Musée du Louvre, Paris

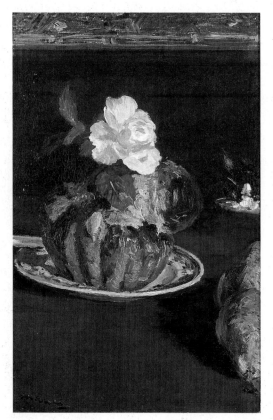

Fig. 35
ÉDOUARD MANET
Still Life with Brioche
c1880. Oil on canvas,
55.2 x 35.2 cm.
Carnegie Museum of Art,
Pittsburgh, PA

Similar in size to *Grapes and Pomegranates* (Plate 41) this work is quite different in tone and feeling. The paintings may have been shown as a pair and the artist clearly intended them to contrast with each other. The composition of *The Brioche* appears to be simpler but is in fact more contrived. Its simplicity contrasts with the looser, more abundant feeling of *Grapes and Pomegranates*. Both paintings represent a contrast in the study of textures. The softness of the brioche at the centre of the composition contrasts with the brittle quality of the porcelain water jug and the matt texture of the peaches and macaroons counterbalances the luscious flesh of the grapes and pomegranates. The objects such as the delicate Meissen tureen and the Bohemian glass carafe are tight-lidded, unlike the half-drunk glass of wine and the opened pomegranates. The restraint of *The Brioche* is a perfect balance to the abundance of the *Grapes and Pomegranates* but both pictures within themselves represent a harmonious whole. Manet may have been inspired by this work when he painted his *Still Life with Brioche* (Fig. 35) in around 1880.

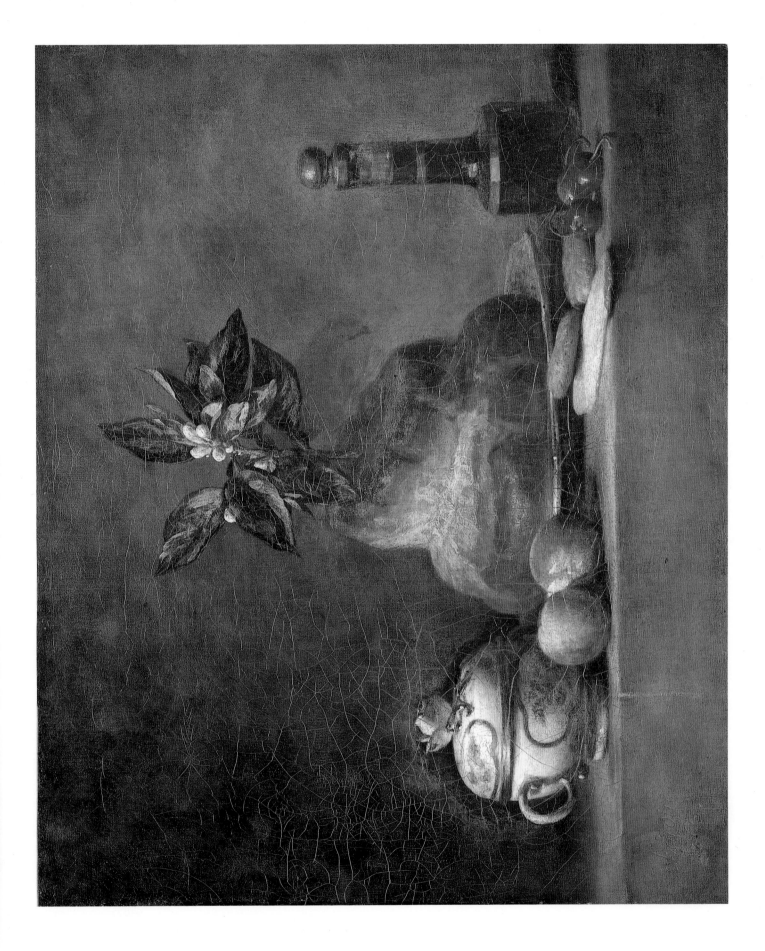

Wild Duck with an Olive Jar

1764. Oil on canvas, 152.5 x 96.5 cm. Museum of Fine Arts, Springfield, MA

In 1765 Chardin, who was then 66, sent eight pictures to the Salon including this one. Its unusually large size – it measured over five feet in height – combined with the elegant oval design suggests that it was a specific commission from a patron. Interestingly it reproduces many of the elements from Chardin's Salon exhibit of the previous year, *The Olive Jar* (Plate 38). Here we see the same pâté with the knife and board, the Meissen bowl, the olive jar, marzipan biscuits, Seville orange and wineglass. By adding the wild duck and the white table-cloth, however, Chardin completely transformed the elements from an earlier painting into a startling new image. Perhaps a visitor to the 1863 Salon was so impressed with *The Olive Jar* that he commissioned this work. Unfortunately his or her identity is unknown since the painting's history prior to the nineteenth century is unrecorded. The wild duck in this picture recalls the green-neck duck which Chardin had painted about 30 years previously (Plate 6) and to compare the two paintings is to witness the artist's remarkable development. Nevertheless, simplicity and truth to nature remain at the essence of both these works just as they are at the essence of Chardin's art. The *Wild Duck with an Olive Jar* has been described as one of Chardin's *chefs d'œuvre* and we can only reiterate the words of Diderot: 'If a connoisseur can manage to have only one Chardin, let him have this one.'

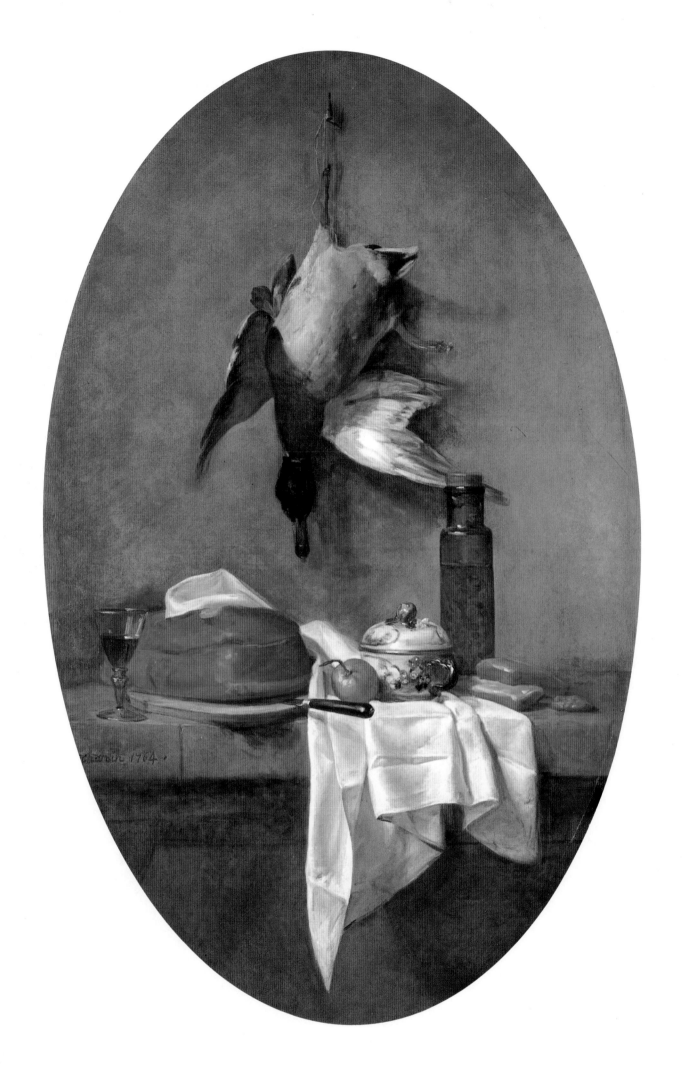

The Attributes of Music

1765. Oil on canvas, 91 x 145 cm. Musée du Louvre, Paris

In 1764 Cochin, Chardin's close friend and Secretary to the Academy, submitted to the Marquis de Marigny a decorative project for two rooms in the château de Choisy – the Salle des Jeux and the Salon de Compagnie. The château had been designed and built for the Duchesse de Montpensier by Jacques Gabriel and later became one of the residences of Louis XV. At Cochin's suggestion, Chardin was commissioned to paint three canvases to go over the doors in the Salon de Compagnie, the subjects being *The Attributes of the Arts* (Fig. 36), *The Attributes of the Sciences* and *The Attributes of Music*. Chardin's paintings remained in the château until the Revolution and are now in the Louvre although one, *The Attributes of the Sciences*, has disappeared. It was probably sold by the Revolutionary Administration.

The instruments depicted here are a violin, a lute, court bagpipes, a flute and a trumpet. To the right is a music stand and candle. This painting recalls Chardin's earlier commissions for Count de Rothenbourg (Plate 7 and Fig. 20) but the arrangement of the objects is now tighter and more controlled. The elegant, elongated oval design is also more suited to a royal residence. As usual Chardin contrasts colours and textures. The soft velvet of the bagpipes contrast with the hard wood of the lute and the red drapery of the ledge with the green of the music stand. The success of this work led to Chardin receiving another royal commission in 1766 when he was requested to paint *The Attributes of Military Music* and *The Attributes of Civilian Music* (both in private collections) for the royal château at Bellevue which had been built in 1748 for Madame de Pompadour.

Fig. 36
The Attributes of
the Arts
1765. Oil on canvas,
91 x 145 cm. Musée du
Louvre, Paris

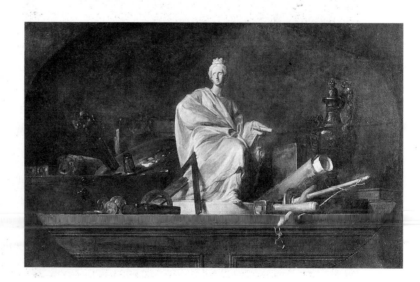

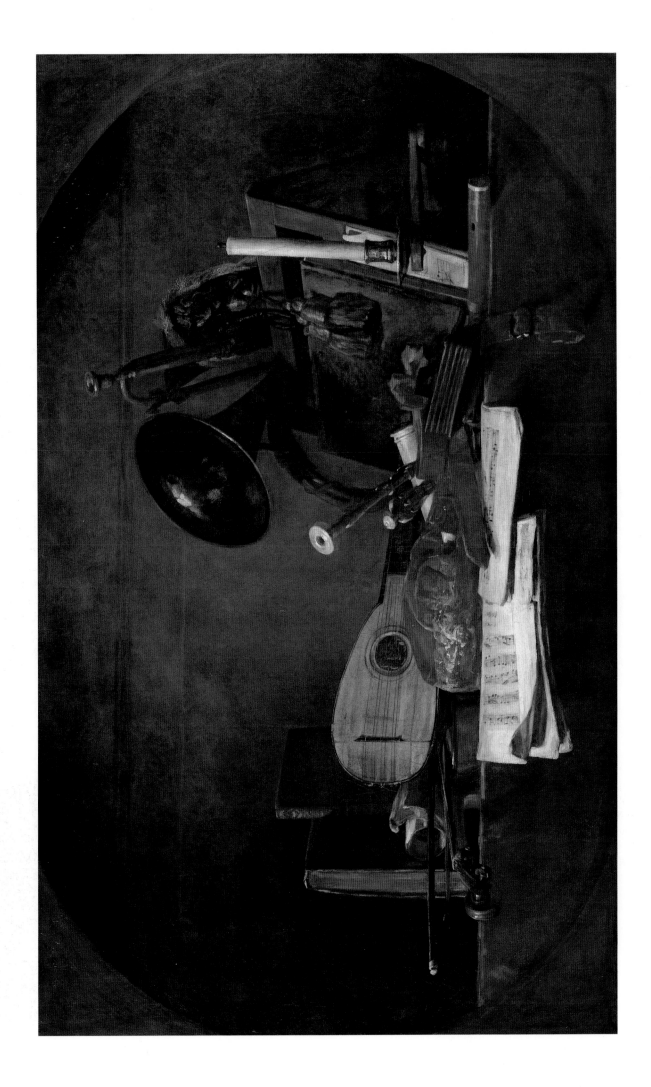

1766. Oil on canvas, 112 x 140.5 cm. Hermitage Museum, St Petersburg

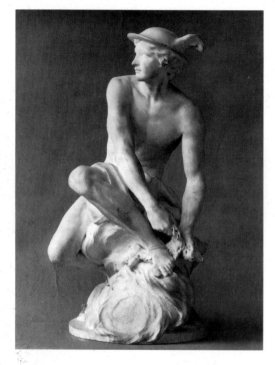

Fig. 37
JEAN-BAPTISTE
PIGALLE
Mercury
1744. Marble, h58 cm.
Musée du Louvre, Paris

This canvas, designed as an overdoor, was commissioned from Chardin by Catherine the Great for the conference hall of the Academy of Fine Arts in St Petersburg. The building had been designed by the French architect, Vallin de la Mothe (1729–1800), who also designed the Hermitage. Catherine collected works of art on a grand scale and organized her purchases by ordering her ambassadors throughout Europe to keep her informed of auctions and private collections that were up for disposal. In Paris she mainly used the Ambassador Dimitri Galitzin, but also Diderot, who had acquired a reputation as an arbiter of taste since the publication of his Salon criticism in his *Literary Correspondence* from 1759 onwards. Catherine loved Chardin's work and owned four of his paintings in addition to this one. They were the *Girl with Shuttlecock* (Plate 23) and versions of *The House of Cards*, *Saying Grace*, and *The Laundress*. When this painting was shipped to St Petersburg in 1766, Catherine was so pleased with it that she diverted it from its destination, the Academy of Fine Arts, in order to place it in her personal collection.

In this painting Chardin pays homage to his friend, the sculptor Pigalle. The composition is dominated by the plaster of Pigalle's *Mercury* (Fig. 37) symbolizing the domination of sculpture over all the other arts. Chardin himself owned a version of the plaster. The black ribbon with the cross of the Order of St Michael also alludes to the sculptor's reputation since it was offered to him by Louix XV in 1765, the year before this work was painted. Chardin painted another version of this subject for Pigalle, which is recorded in the sculptor's posthumous inventory and which is today in the Minneapolis Institute of Fine Arts. Diderot, who was influential in the acquisition of many of Catherine's paintings, gave a version of this work unequivocal praise when it was shown at the Salon of 1769: 'Chardin is an old magician whom age has not robbed of his genius.'

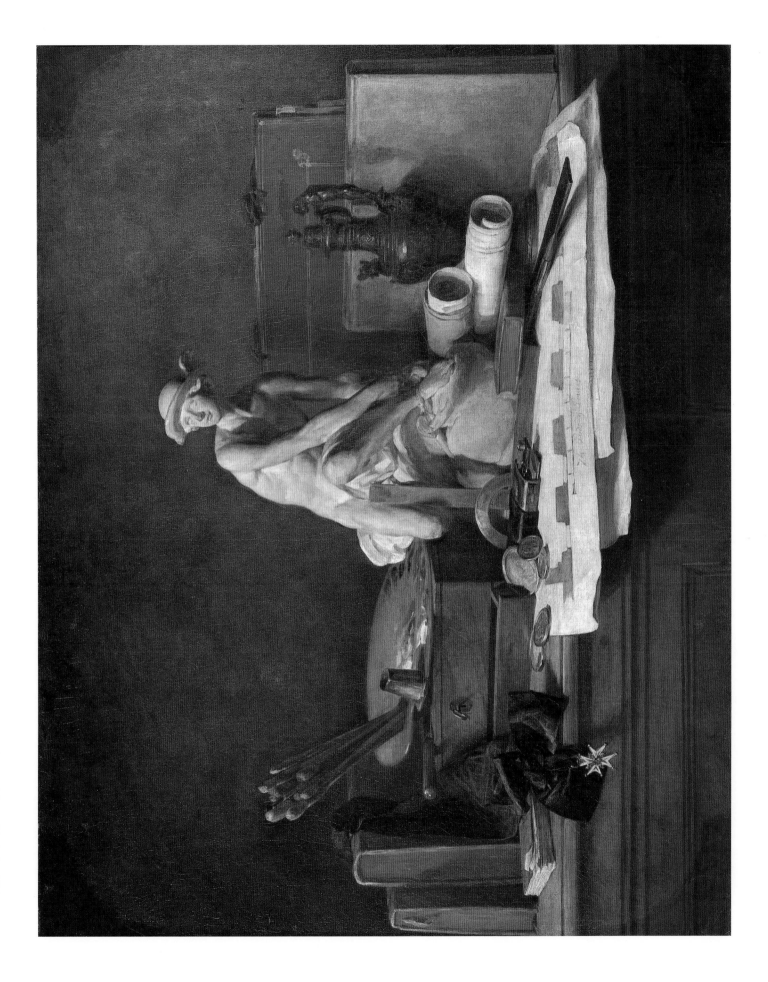

A Basket of Peaches

1768. Oil on canvas, 32.5 x 39.5 cm. Musée du Louvre, Paris

This painting is Chardin's last dated still life. It was shown at the Salon of 1769 with its companion piece *A Basket of Grapes*, formerly in Henry de Rothschild's collection but destroyed during the Second World War. The extreme simplicity which characterized the *Basket of Wild Strawberries* (Plate 39) also characterizes this work. In both paintings the artist has arranged the fruit in a woven willow basket and here he intersperses them with leaves. Whereas the strawberries look cool and freshly picked beside the glass of water and the white carnations, this work is warmer in feeling, the walnuts and wine conjuring up images of autumn and the turning season.

This work belonged to Laurent Laperlier (1805–78), one of the great nineteenth-century collectors of Chardin's paintings. A French government official in the colonial service, part of his collection was sold in 1867 when this painting was acquired by the Louvre.

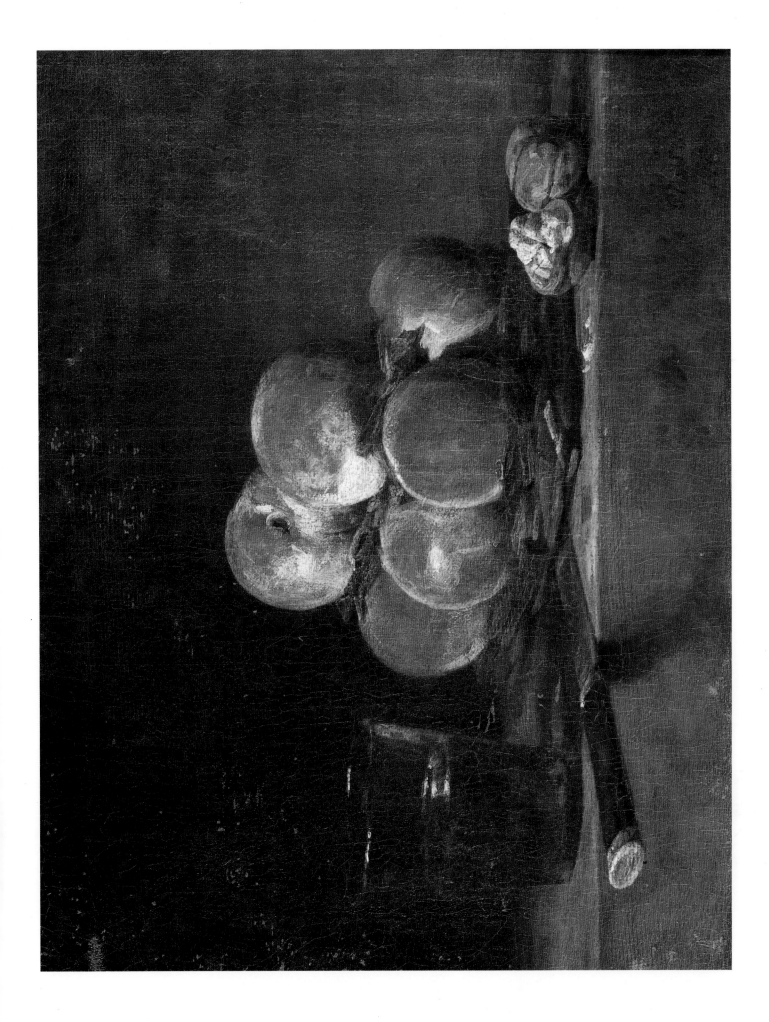

Self-portrait with an Eye-shade

1775. Pastel on paper, 46 x 38 cm. Musée du Louvre, Paris

Fig. 38
Self-portrait
1771. Pastel on paper,
46 x 37.5 cm.
Cabinet des Dessins,
Musée du Louvre, Paris

Fig. 39
Portrait of Madame
Chardin
1775. Pastel on paper,
46 x 38.5 cm.
Cabinet des Dessins,
Musée du Louvre, Paris

By the early 1770s, Chardin was unable to work in oils because of an eye affliction and turned instead to drawing in pastel. At the Salon of 1771, he surprised his critics by showing three pastel heads including the famous *Self-portrait* in the Louvre (Fig. 38). Up to the year of his death, 1779, he exhibited a number of pastel portraits at the Salon, frequently of children and fellow artists.

This *Self-portrait with an Eye-shade* was shown at the Salon of 1775. Chardin chose to portray himself informally dressed, wearing a white linen wrap around his head knotted with a pink printed ribbon, his eye-shade and an old striped scarf around his neck. Although his glasses make him look severe, his expression is direct and his eyes are still intense, and though his dress is casual, the scarf and head-dress have been artfully arranged. Proust described the artist's appearance as that of an 'old eccentric English tourist'.

Chardin exhibited a companion piece to this pastel at the Salon of 1775, the *Portrait of Madame Chardin* (Fig. 39). The Goncourts, writing in 1864, described it as a brilliant study of old age and compared both pastels to the work of Rembrandt.

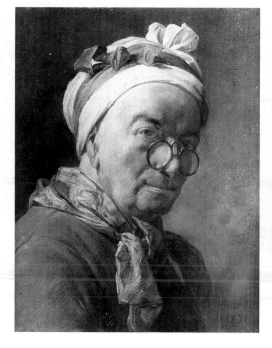

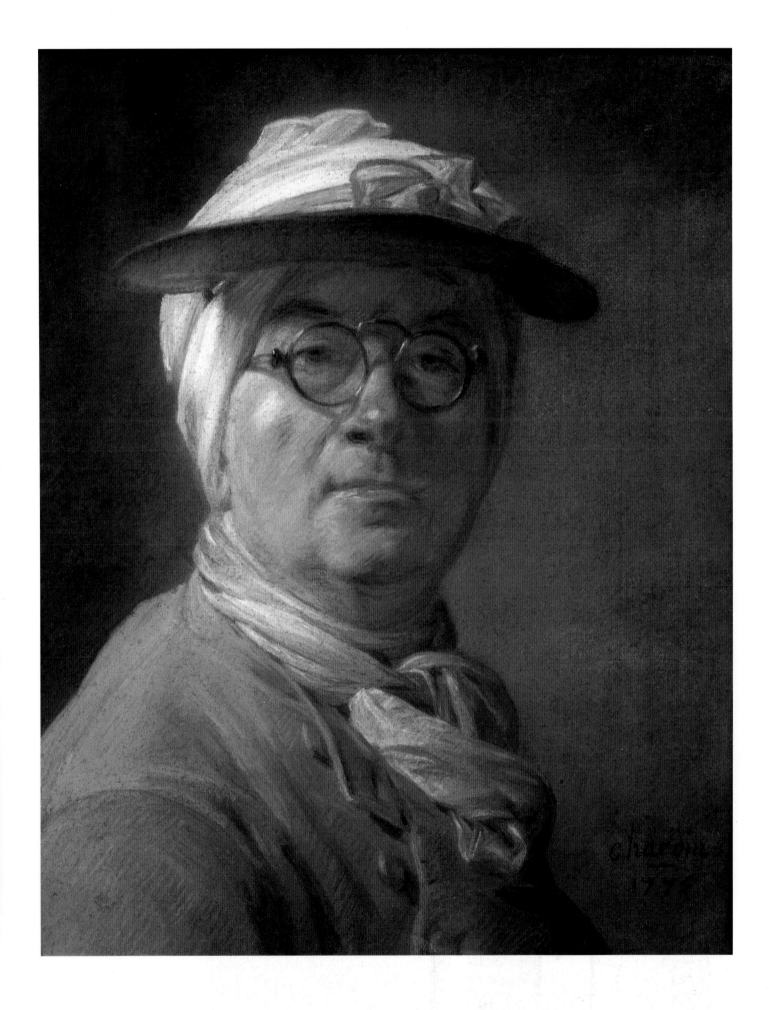

Self-portrait at an Easel

1779. Pastel on paper, 40.5 x 32.5 cm. Musée du Louvre, Paris

This moving self-portrait may be one of the three 'Studies of Heads' which Chardin showed at the Salon of 1779. The critics, while reminding the public that the artist was now in his eightieth year, praised his bold use of colour and fresh, brilliant touch. One critic wrote touchingly: 'Cherished by the Muse, he will always be thirty years old.'

Compared to the self-portrait of 1775 (Plate 47), Chardin portrays himself here less self-assured. His face is thinner and older yet he still fixes us with an artist's steady, penetrating gaze. The bright red of the pastel chalk he is holding in thumb and forefinger contrasts with the brilliant blue of his elegantly knotted head-band and the white of his bonnet. It is known that Chardin studied Rembrandt in his last years and this self-portrait may have been drawn in homage to him. This is the artist's last self-portrait. He died the year it was produced, fittingly, in his apartment in the Louvre.

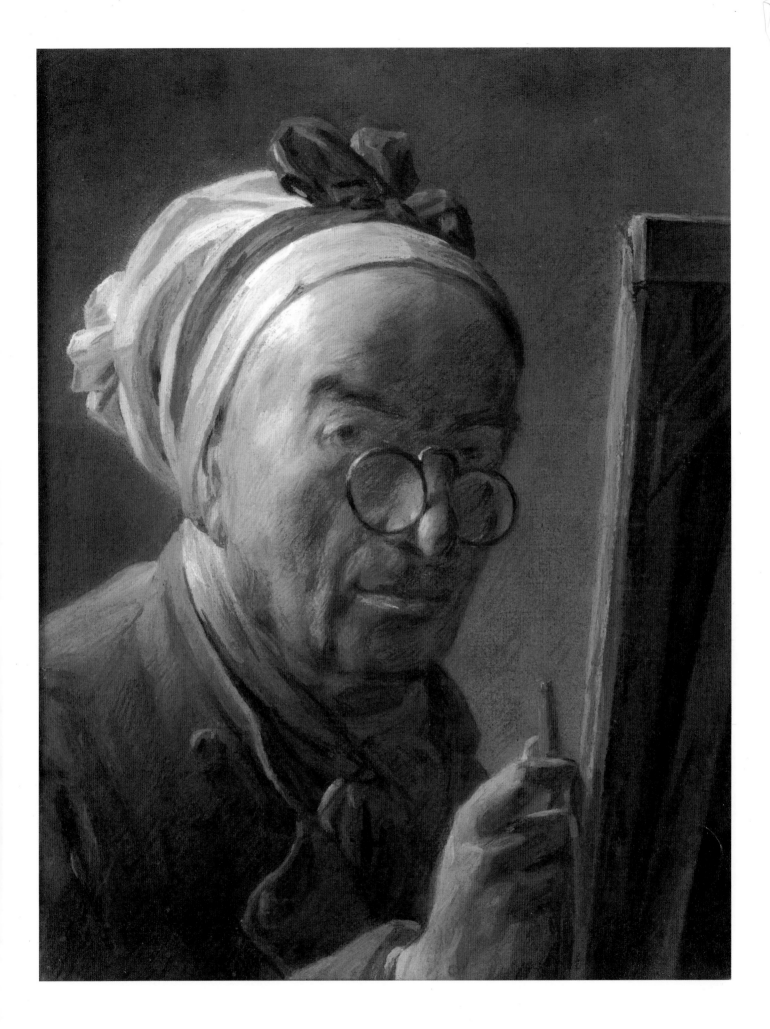

PHAIDON COLOUR LIBRARY

Titles in the series